Zen Doodle Cats

Drawing Zen Doodle Cats Made Easy

By Daniele Ling

Copyright©2016 by Daniele Ling
All Rights Reserved

Copyright © 2016 by Daniele Ling

All rights reserved. No part of this publication may be reproduced, distributed, or transmitted in any form or by any means, including photocopying, recording, or other electronic or mechanical methods, without the prior written permission of the author, except in the case of brief quotations embodied in critical reviews and certain other noncommercial uses permitted by copyright law.

Table of contents

Introduction	**5**
How to Draw Cats	**7**
Chapter 1 How to Draw Maggie	**12**
Chapter 2 How to Draw Bella	**21**
Chapter 3 How to Draw Casper	**32**
Chapter 4 How to Draw Pumpkin	**45**
Chapter 5 How to Draw Kiki	**55**
Chapter 6 How to Draw Callie	**68**
Conclusion	**78**

Disclaimer

While all attempts have been made to verify the information provided in this book, the author does assume any responsibility for errors, omissions, or contrary interpretations of the subject matter contained within. The information provided in this book is for educational and entertainment purposes only. The reader is responsible for his or her own actions and the author does not accept any responsibilities for any liabilities or damages, real or perceived, resulting from the use of this information.

The trademarks that are used are without any consent, and the publication of the trademark is without permission or backing by the trademark owner. All trademarks and brands within this book are for clarifying purposes only and are the owned by the owners themselves, not affiliated with this document.

Introduction

Whether you possess cats or not; you just cannot resist these adorable creations of God. No other pet can match the cuteness of these fur balls. You love them when they roll up around your knees. The added benefit to have cats is that they are not very demanding animals. Just food on time and love without time- these two things are sufficient to keep them happy. Cats are playful, charming, cute and loving creatures.

After dogs, cats are the most owned pets all over the world. Millions of cats have found their home in the houses of Americans. Cats are a little naughty but rarely troublesome. Artists always love drawing their life on canvas. As an artist, you would definitely want to take cats as your subject.

You can never make a cat to sit and pose for you. Therefore, you can either picture them or use your own imagination to draw a

cat. Either way, you have to know the tricks of drawing a perfect cat. You need to study their anatomy in brief and then put pen to paper. It is easier to draw Zen Doodle cats since you do not have to draw the actual skin or fur of the cats. But, the outline of the cat will come out well only if you know the basic anatomy of cats.

In this book, you will find a brief introduction to drawing cats. In the subsequent chapters, you will find step-by-step tutorials on how to draw different cats using the Zen Doodle technique. While drawing Zen Doodle cats, you need to keep one thing in mind- draw each step on paper as you study them. Only then, the book will prove to be useful to you.

Best of luck for your new journey with this book!

How to Draw Cats

Artists always have some subjects that are close to their heart. For many artists, it is cats. If you are also one of those cat-lovers who would like to draw them on paper, you can even pursue a career as an animal artist. You will need only some of these tips while drawing Zen Doodle cats, but they will anyhow come handy when you have to draw real-life cats. Let us get started on drawing cats.

Use live cats as your subject if your cat is patient enough to sit for a few moments. If it jumps out every now then, you can photograph them. However, drawing from a live animal gives a more learning experience. Rather than taking photographs from internet, click them on your own. Your emotions will trigger better drawings. Nevertheless, if you are only a beginner, you can take reference from third party resources without hesitation.

Begin with simplest, largest shapes

To start drawing a cat, look at the photograph you have taken as a reference. Notice the largest shape in the body of cat. Do not follow the generic advice on drawing ovals and circles. Whatever you observe biggest part in your cat, just draw it first. Then, you can come to smaller details.

Do not shy away from erasing

You can take a kneaded eraser to erase the mistakes you do while drawing. Artists are always taught not to use an eraser. However, this does not mean that you cannot use it at all. Keep its use minimal but do use it if you have to. You will need time to draw things perfectly in the first attempt. You can use a 2B pencil to draw the outlines or details you feel you will need to erase later. Use 6B pencil at last.

To draw the head

Observe the head correctly and accurately. Then, you can draw the parts of your cat's head on paper.

Eyes

Locate the position of eyes in the head of your cat. Notice the distance between them and measure it with your pencil. Set a benchmark for measuring your subject. You can use the sharpened portion or even the tip of your pencil as a measuring scale. The eyeballs are round; therefore, the eyes should be made such that they do not seem flat. Locate the distance of eyeball into the socket of eye. Notice the shapes just about the eyes. When you get these details correctly, you can capture likeness and expression.

Nose

Nose does not have any well-defined edge. If you do not see a hard edge around the nose, do not draw it just because you think nose should have a shape. Notice the shape of nose. Is it smooth, or flat? What is the size of nostrils? Notice the distance between the upper lip and the nose. Nose and eyes determine the overall appearance of a cat.

Mouth

Just like nose, you might not find well-defined edges of your cat's mouth. Mouth of a cat is in fact almost joined with the nose. The mouth protrudes a little outward and gives the distinct sharp shape to the head of a cat. The lips are very soft and almost invisible.

Ears

The ears are protruding upward from the head. They are set high on a cat's skull. They are generally small in proportion with the head. They lie on the head in rest when the cat is not alert, but are raised high once the cat is alarmed. In addition, there is heavy fur on the ears of some cats. Notice the size, texture, and thickness of this fur and draw them carefully.

Chapter 1 How to Draw Maggie

Maggie, the fur ball, wants to play with the kids but the kids are busy in their video games. Therefore, she is trying to play on her own.

Step 1

Draw the basic outline of the cat, Maggie. She is sitting on her hind legs. One of her hands is close to her face and the other hand is resting a little beneath the face.

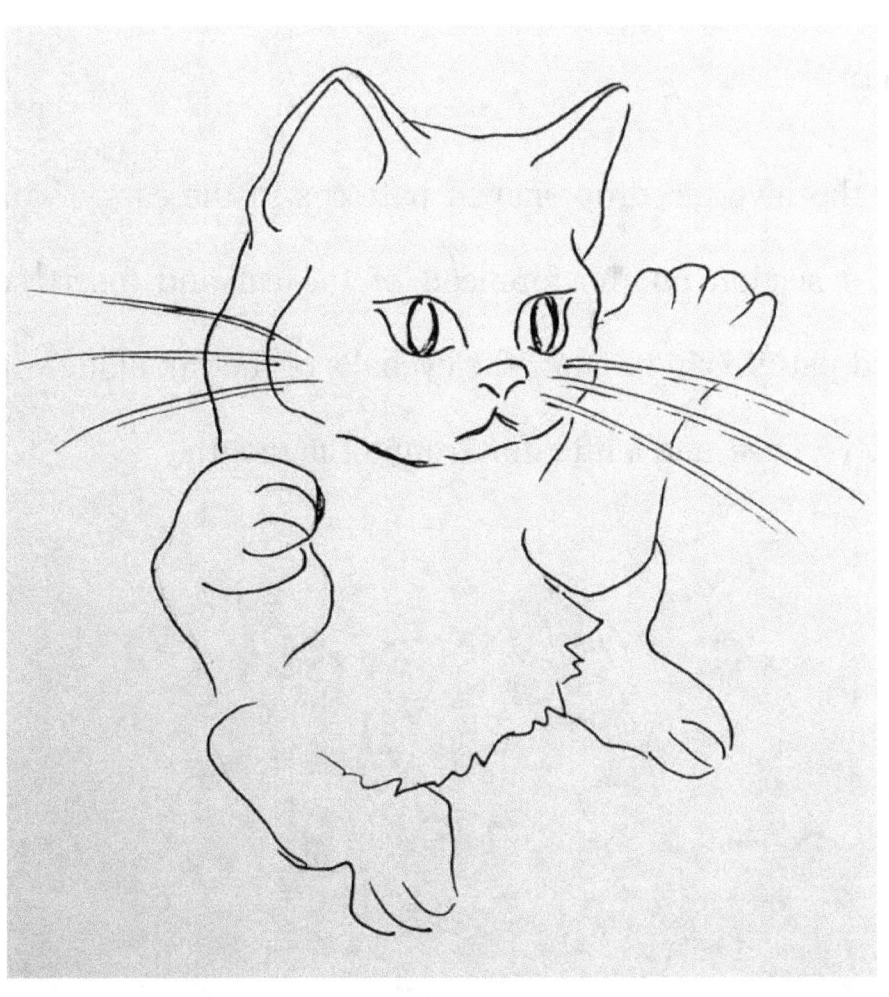

Step 2

Draw the inverted drop shaped patterns in the ears of Maggie. Draw a section on the forehead of the cat and insert scallop shaped patterns in it. Draw the eyeballs of the cat, along with the whiskers, nose, and a little fur around the mouth.

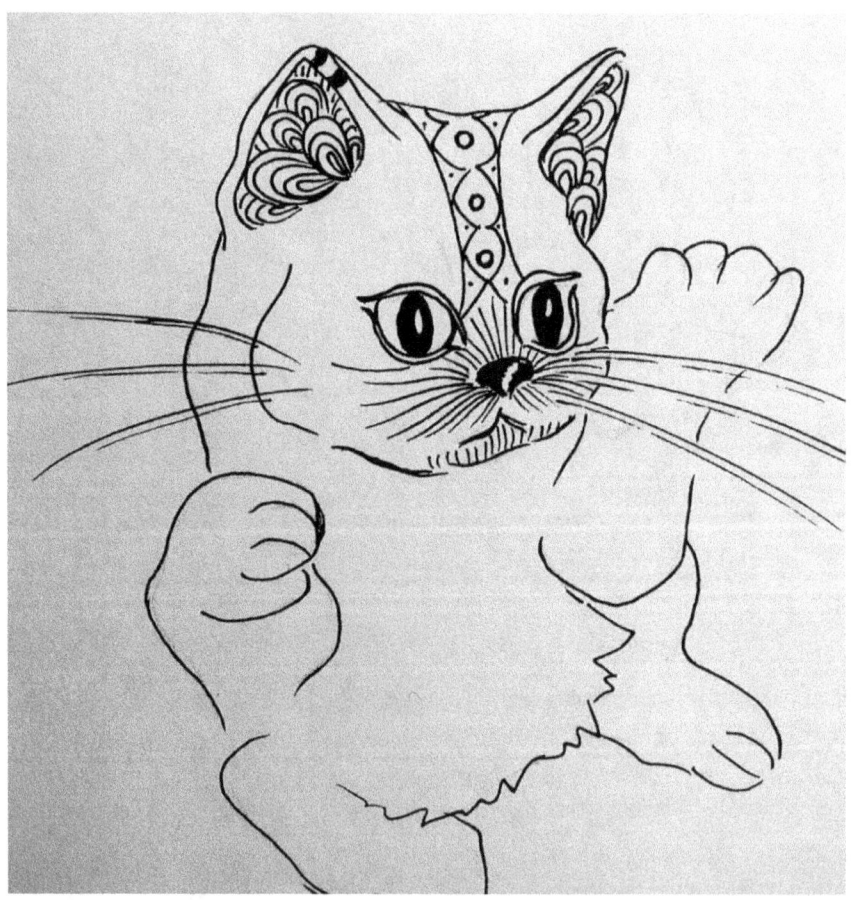

Step 3

Draw the zigzag patterns on the forehead, square chips around the eyes, and circles above the eyes.

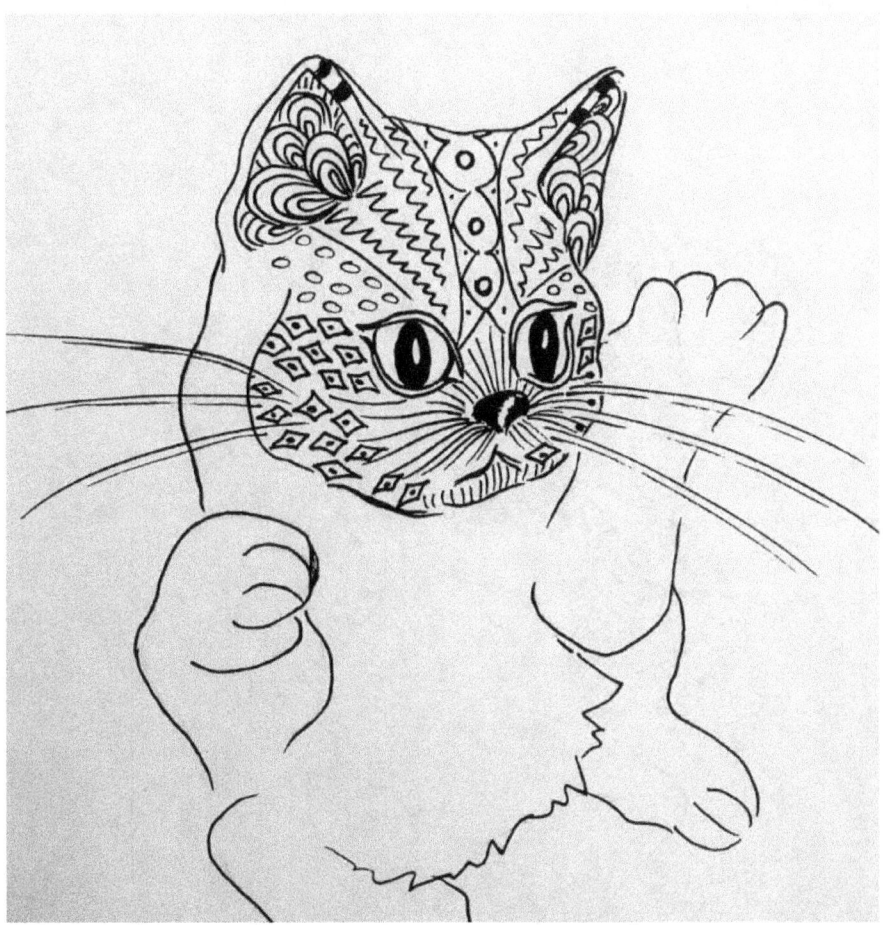

Step 4

Draw infinity signs below the ear. Draw drop shapes together with checks and circles in one hand, swirls, circles, and ovals in the other hand.

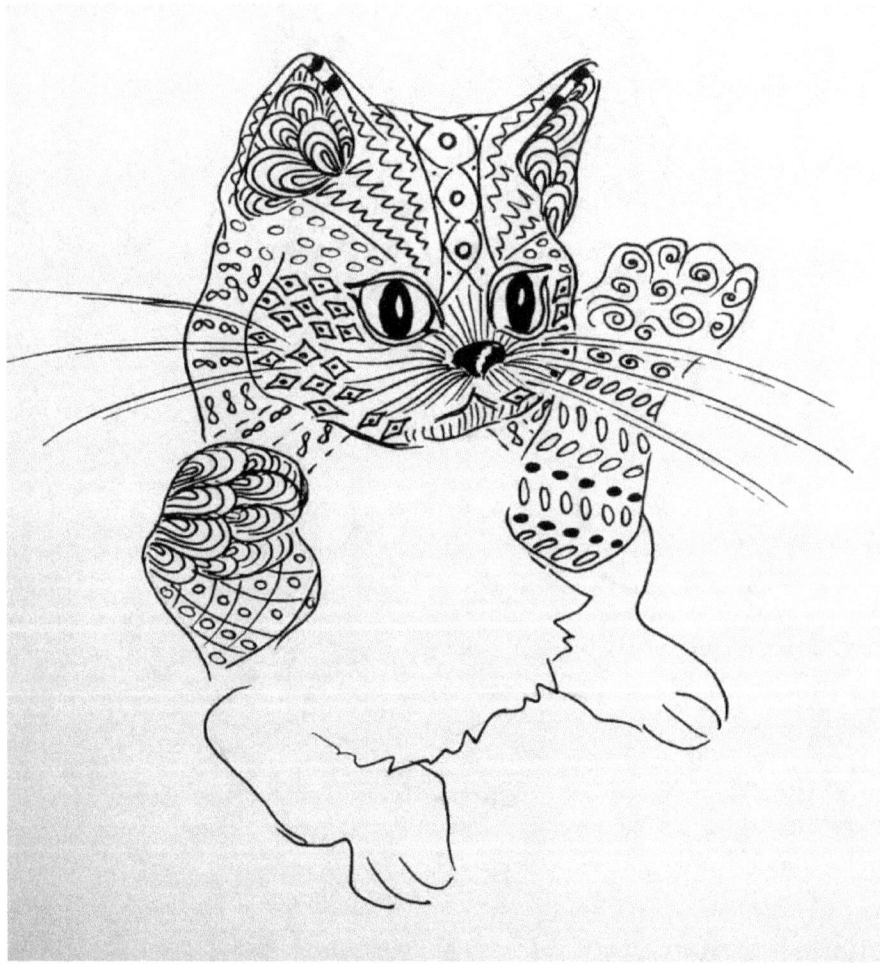

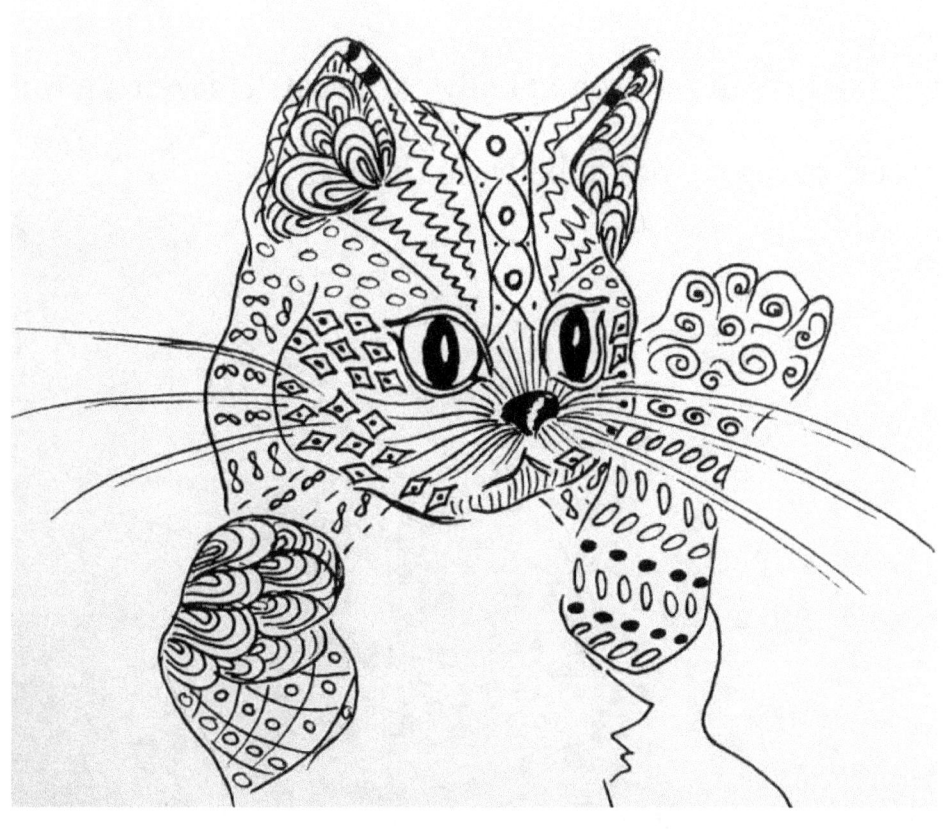

Step 5

Draw a few arcs in the frontal body of the cat. Thicken a few lines and insert zigzag shapes in between the arcs

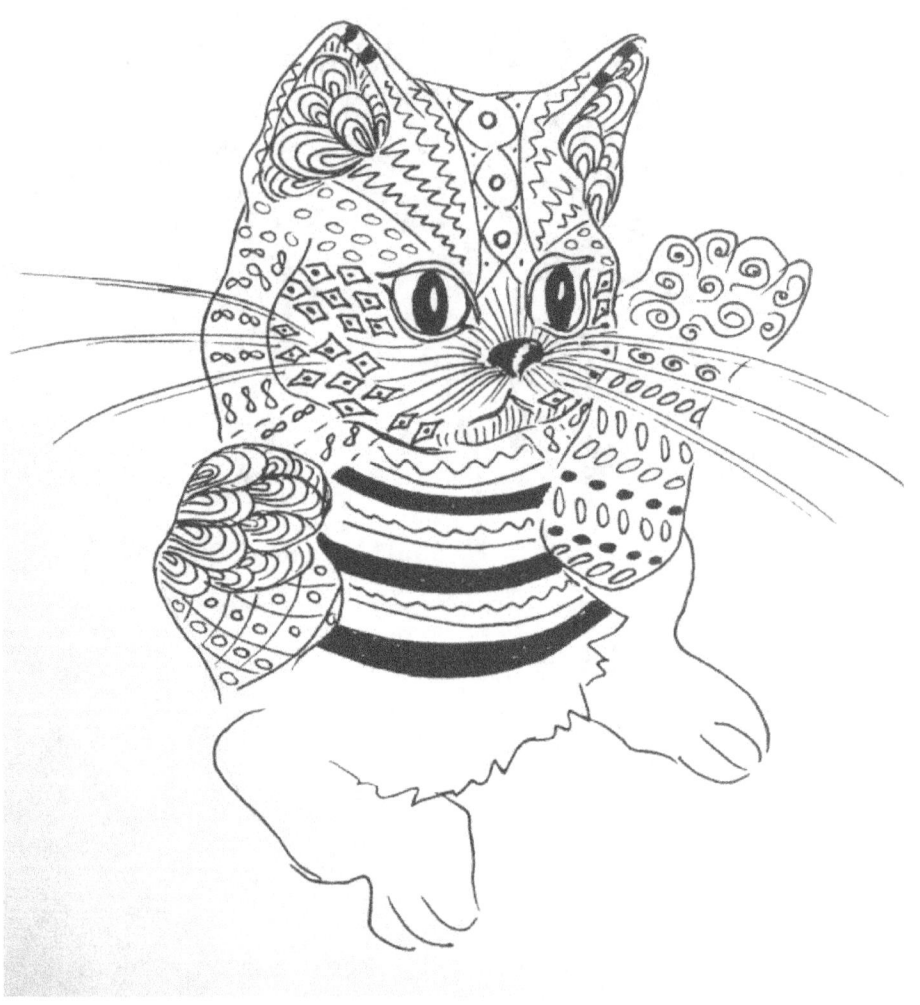

Step 6

Draw star shapes in the lower body of Maggie and some random lines in the feet. Draw some bullets in one feet of the cat and encircle them. Since this is not a real cat, you can take the liberty of drawing the patterns in any manner you like. However, you have to take care that the expression of the eyes does not get lost. The other details are not present to depict the feelings of this cat.

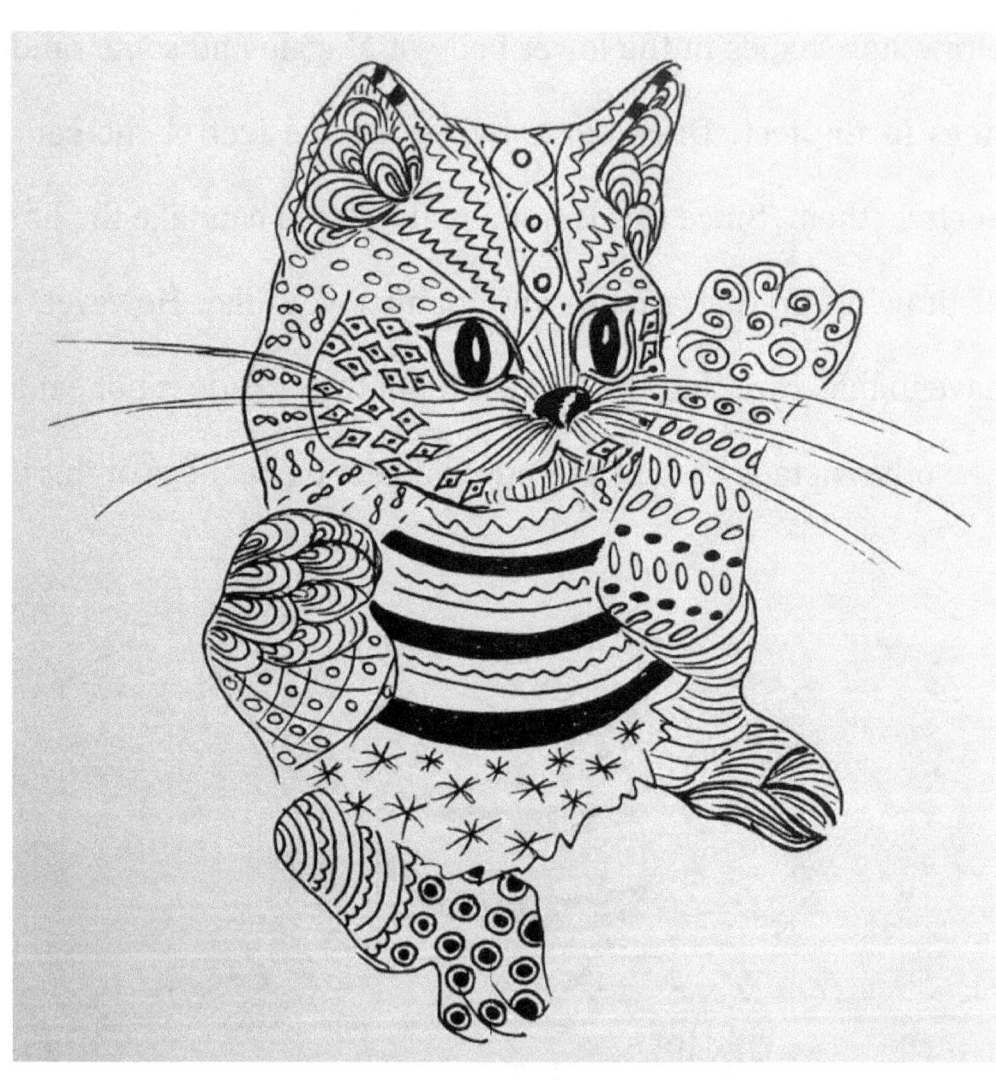

Chapter 2 How to Draw Bella

Bella is an independent and curious cat, who has just found something to play with. Her eyes seem to be playful and interested about something. In addition, her mouth is also playing in conjunction with her eyes and Bella is smiling in a beautiful manner. She is a very hygienic cat, who likes to clean herself all the time. Maybe she has found a bathtub to take a dip. That is why; she has lifted her tail to express a friendly gesture. Let us start drawing this gracious cat.

Step 1

Draw the outline of Bella, who has a round face, large oval eyes, a small nose, a little mouth, and a slender long neck. The ears are protruding upward from the head. Her limbs are not visible; maybe she has hidden them on her back.

Draw small dots inside her eyes. If you draw such dots very closely, the process is called stippling. However, you do not have to stipple here; you just need to draw some loosely placed small dots in the eyes.

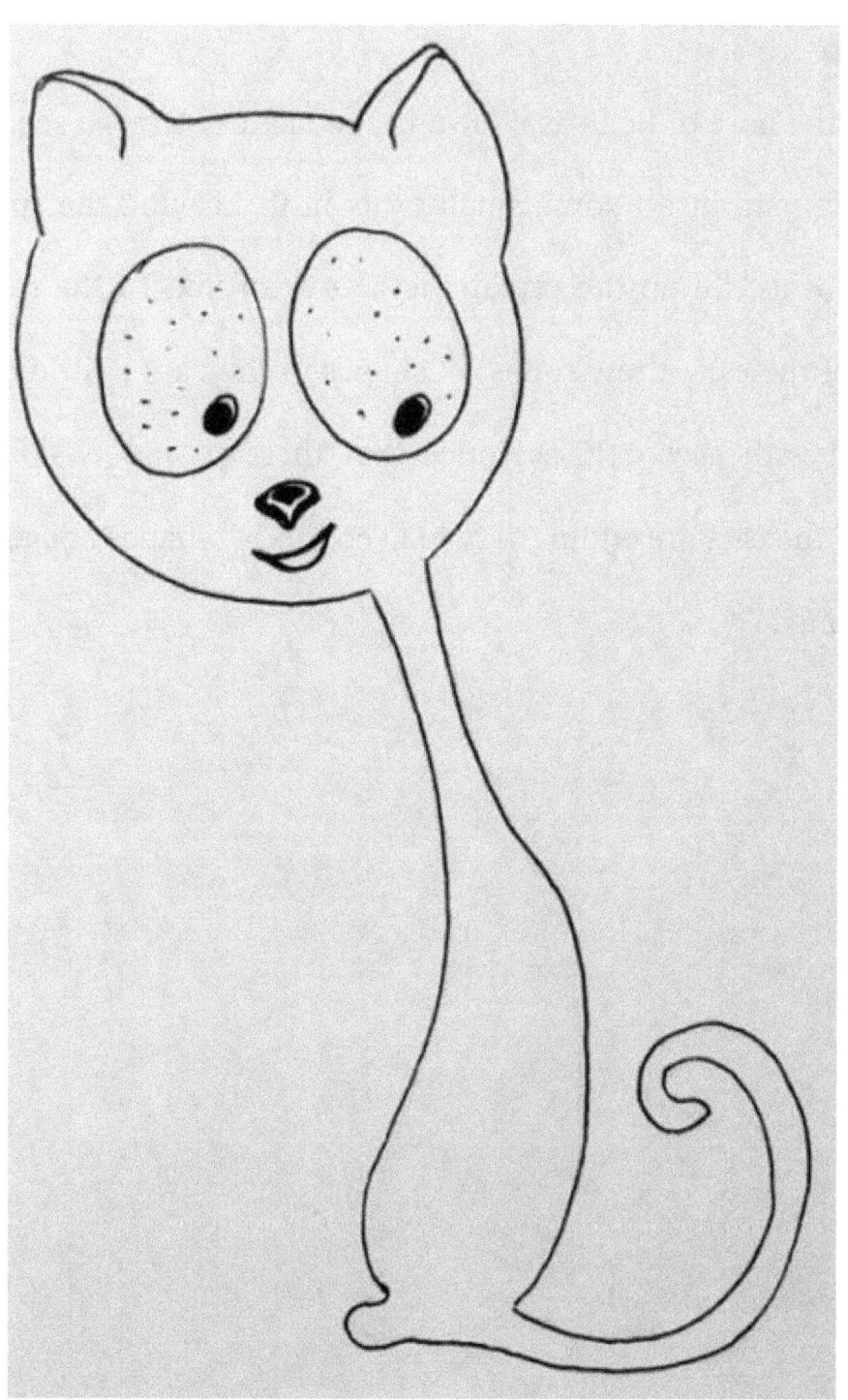

Step 2

Draw the nose of Bella as shown in the picture. Draw a section in the ears and insert some small ovals in it. Leaving the space of these ovals, fill up the remaining area with ink. In the residual area of the ears, draw some "*" shapes in the ears a little closely placed with each other. Notice that there is an invisible line where the ears are ending. Try to keep the "*" shapes above these lines only.

Step 3

On the summit of Bella's forehead, draw some semi-circles and insert scallop patterns between them. Insert some triangles with curved lines on both sides of these patterns you just drew and fill them up with ink alternately. Now, below the ears and on the sides of the face, draw some closely placed moon shapes. They should end where the eyes start. Draw a few flower petals attached to one stem between the eyes and finish them where the nose starts.

Draw inverted drop shapes around the nose and mouth covering almost the complete lower portion of the mouth. In the remaining space, draw small horizontal lines closely placed with each other as we do while depicting water in kids' drawings.

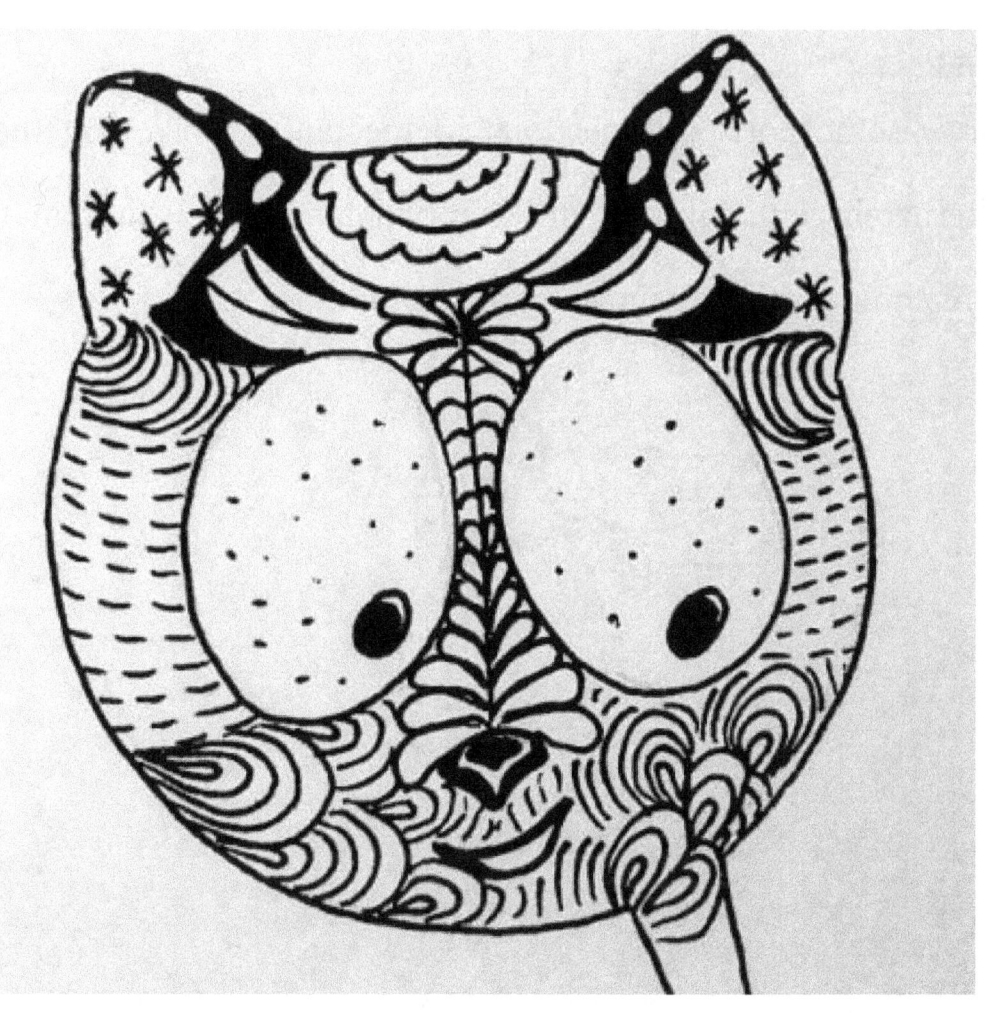

Step 4

Draw some horizontal sections in the tail of Bella. Fill them alternately with ink and draw horizontal parallel lines in the remaining portion as shown in the picture.

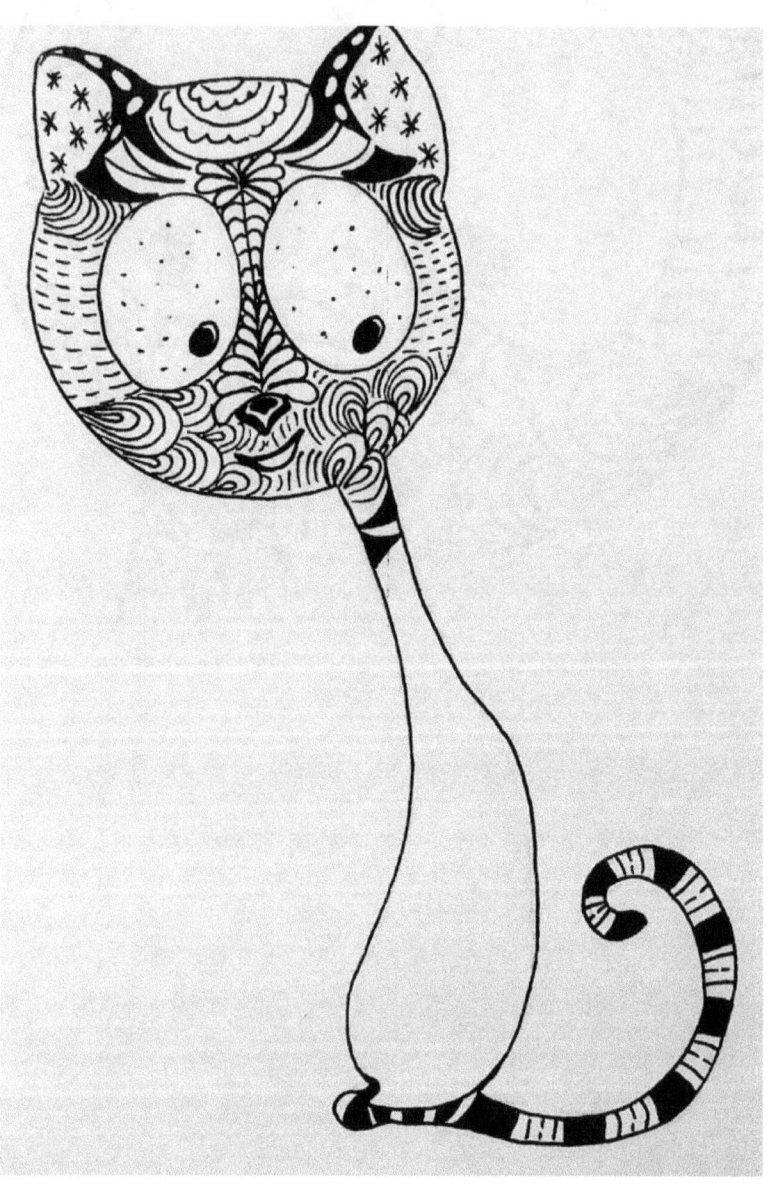

Step 5

Draw three triangles in the upper portion of the neck as shown in the picture. Fill them with ink. Below these triangles, draw some more similar shapes and thicken their outline with ink. Draw some zigzag lines with lower indents below the triangles. Now, draw zigzag lines with deeper indents and insert some small circles between them.

Beginning from the bottom of the cat, draw three large leaves and draw some vertical lines in them. Draw smaller leaves above the larger ones and add some thick bullets above them.

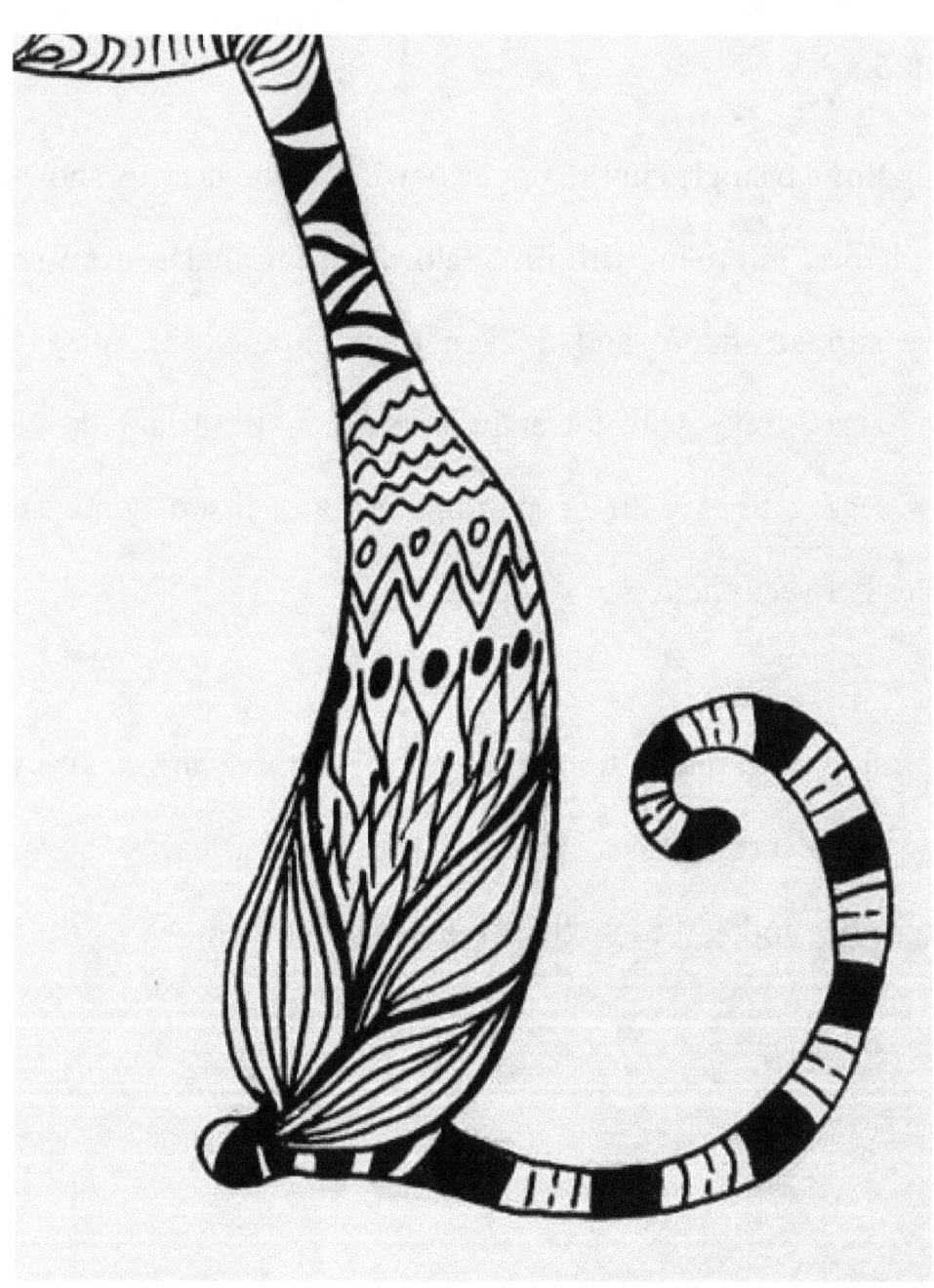

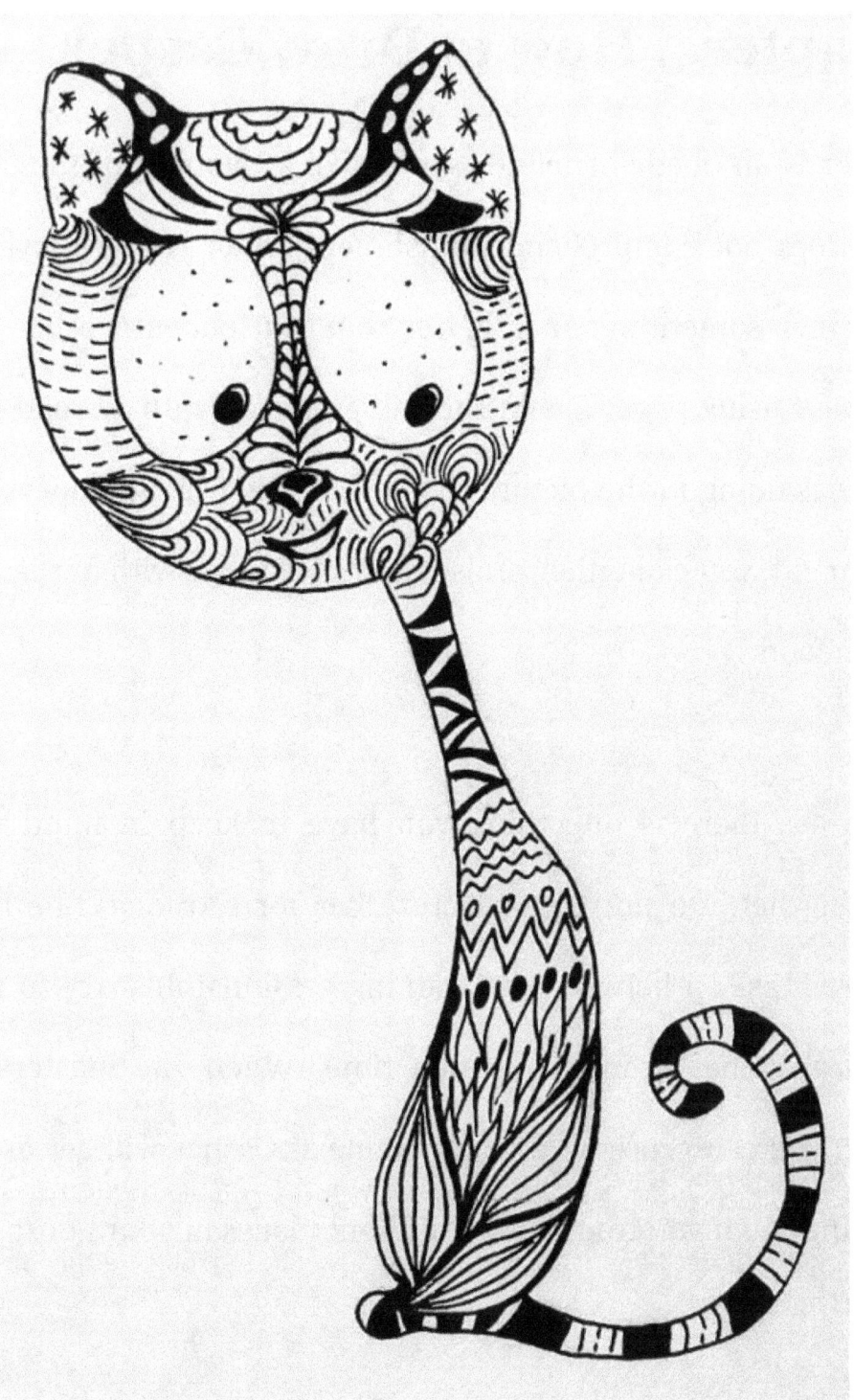

Chapter 3 How to Draw Casper

Casper is an obedient feline. She is like a member of the family who does not comprehend punishment when you are trying to teach her something. It is better that you encourage her good behavior using rewards and she will greet you with a broad smile as she is doing in the picture. If she behaves well and obeys your command, you can either praise her or treat her with her favorite kitten food.

However, there is one thing you have to keep in mind while training her. Do not try to lecture her for too long. She might even fall asleep between the training sessions! Just try to make her learn one command at one time. When she masters one thing, you can proceed to teach the next. Casper will get used to obeying you if you train her at different places in your house.

Step 1

Draw the basic outline of the respectful cat, Bella. Her ears are protruding upward and she has long whiskers, large expressive eyes and a small mouth and nose. She is sitting in a dutiful posture with her forelimbs resting in front of her and her hind limbs folded at the back.

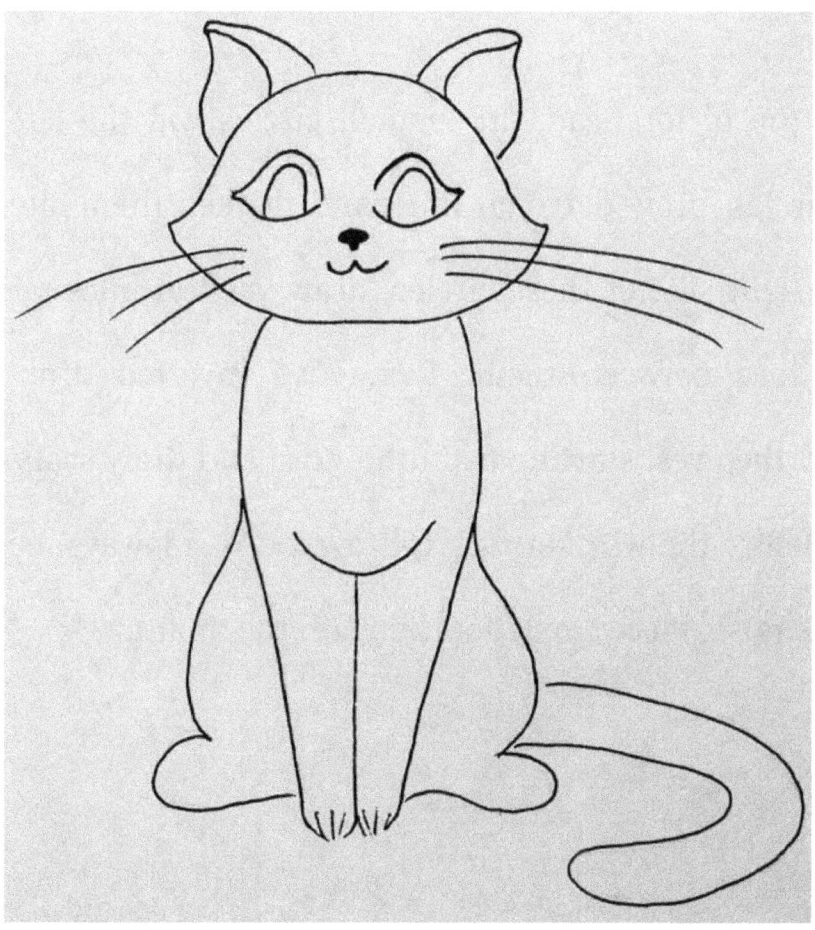

Step 2

Divide the ear in two sections with vertical tilted lines. In the smaller section of left ear, draw vertical lines and fill the broader sections with ink. In the other half, draw checks and insert small dots in the squares. In the smaller section of the right ear, draw horizontal lines closely placed with each other. In the other half, draw checks and fill the squares with ink.

On the top of forehead, draw small circles. On the left side of these circles, draw diagonal lines and thicken them alternately. On the right side of these circles, draw vertical lines and insert zigzag lines between them. Draw five inverted drop shapes between the eyes, starting from the nose and draw scallops over them. Before the whiskers start, draw loops sideways, beginning from the nose. Place small dots beneath the mouth.

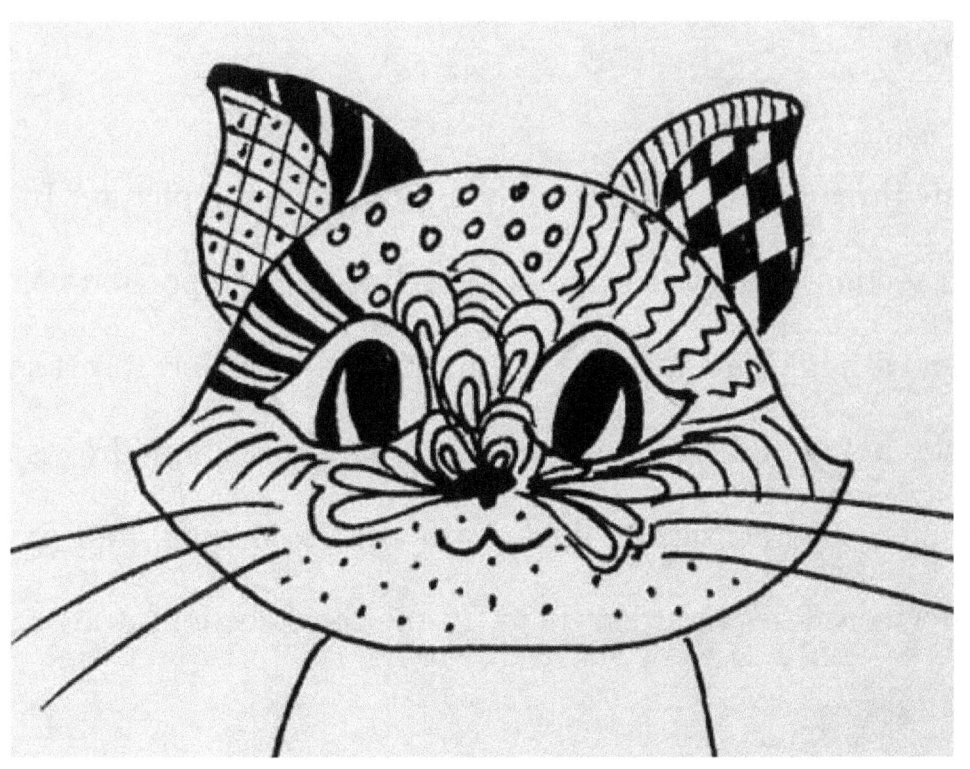

Step 3

Draw three sections in the body as shown in the picture. In the first section, draw two sets of zigzag lines fill the portion behind them with ink leaving some margin from the border. Insert some circles between the zigzag lines. In the second section, draw some parallel sets of zigzag lines with small indents and insert underscore lines between them. In the third section, draw a few small flowers.

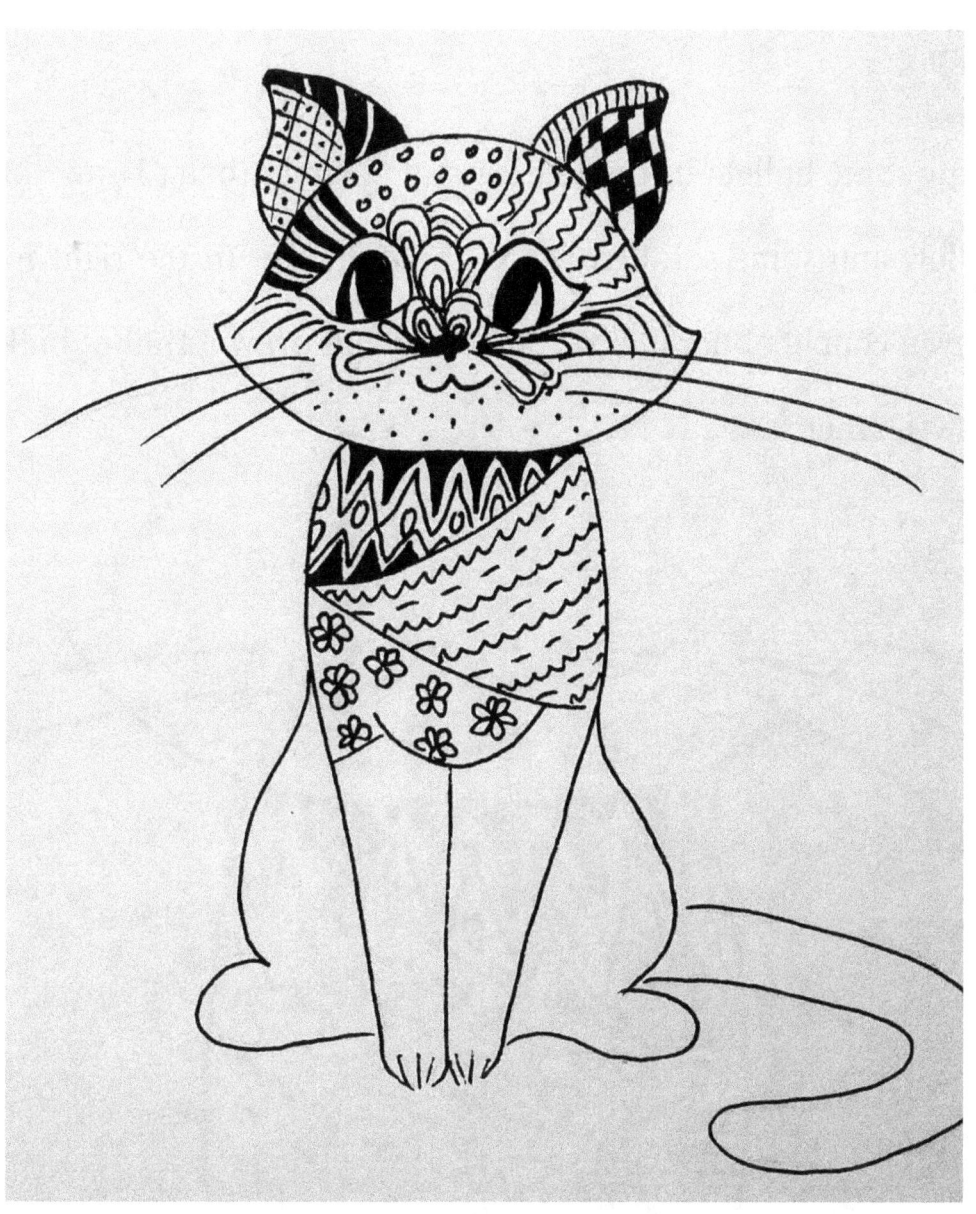

Step 4

Draw some bullets in the left leg and encircle them. Draw some hollow and some solid circles in the right leg. In the right foot, draw a couple of parallel vertical lines and draw a trail of bullets between them.

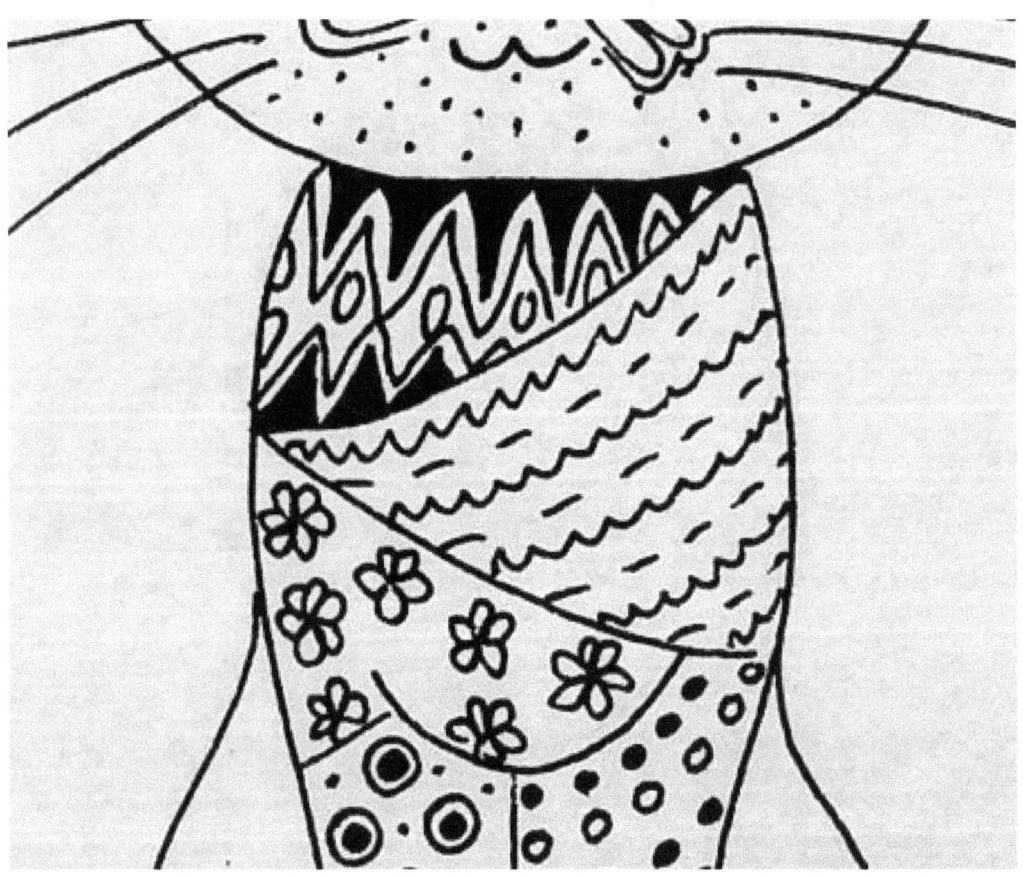

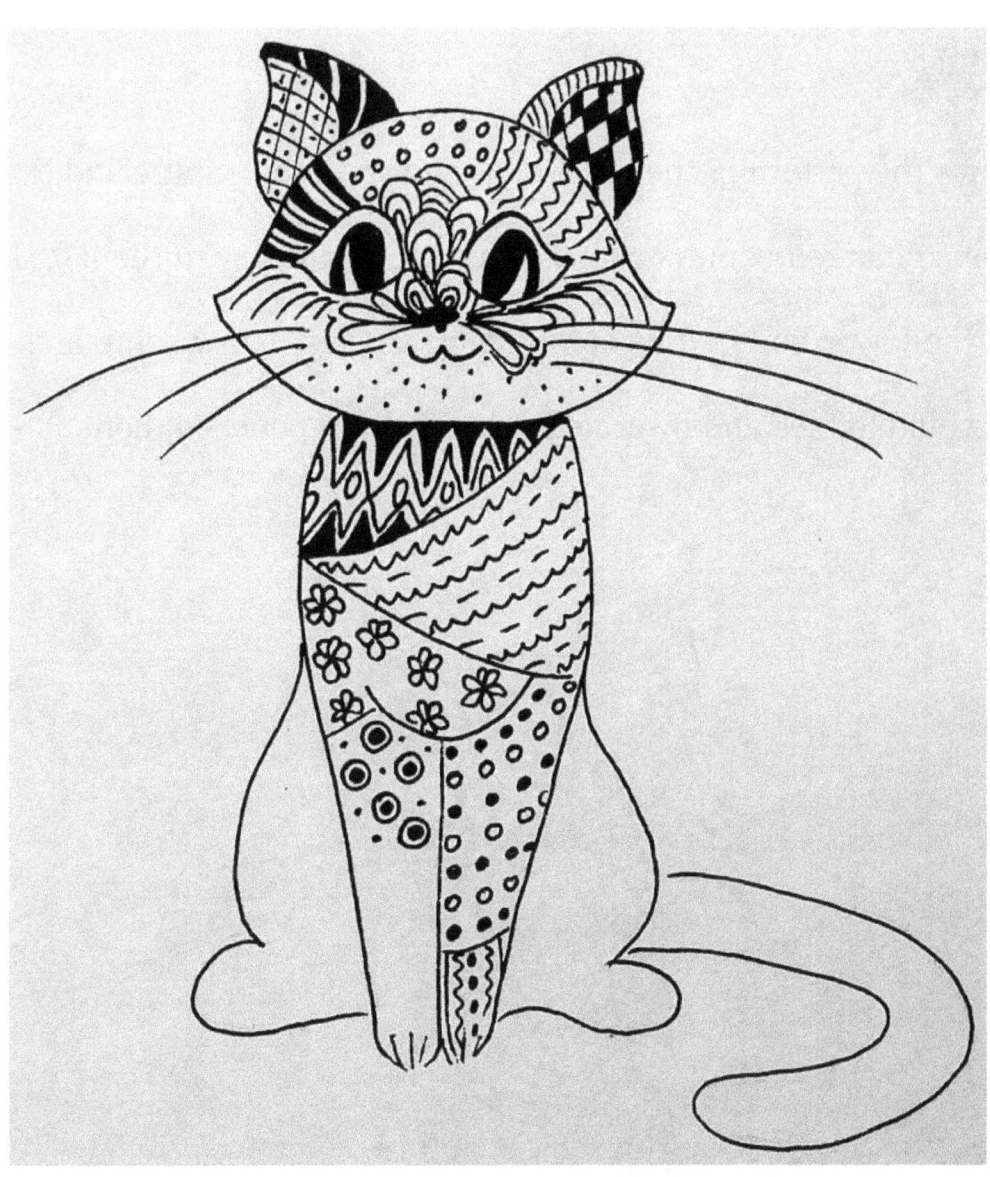

Step 5

Draw the pattern in the left foot as shown in the picture and draw some enlarged comma shapes above this pattern. In the left side of the lower body, draw some onion shapes. Draw some arcs in the hind left leg and insert a few zigzag lines between them.

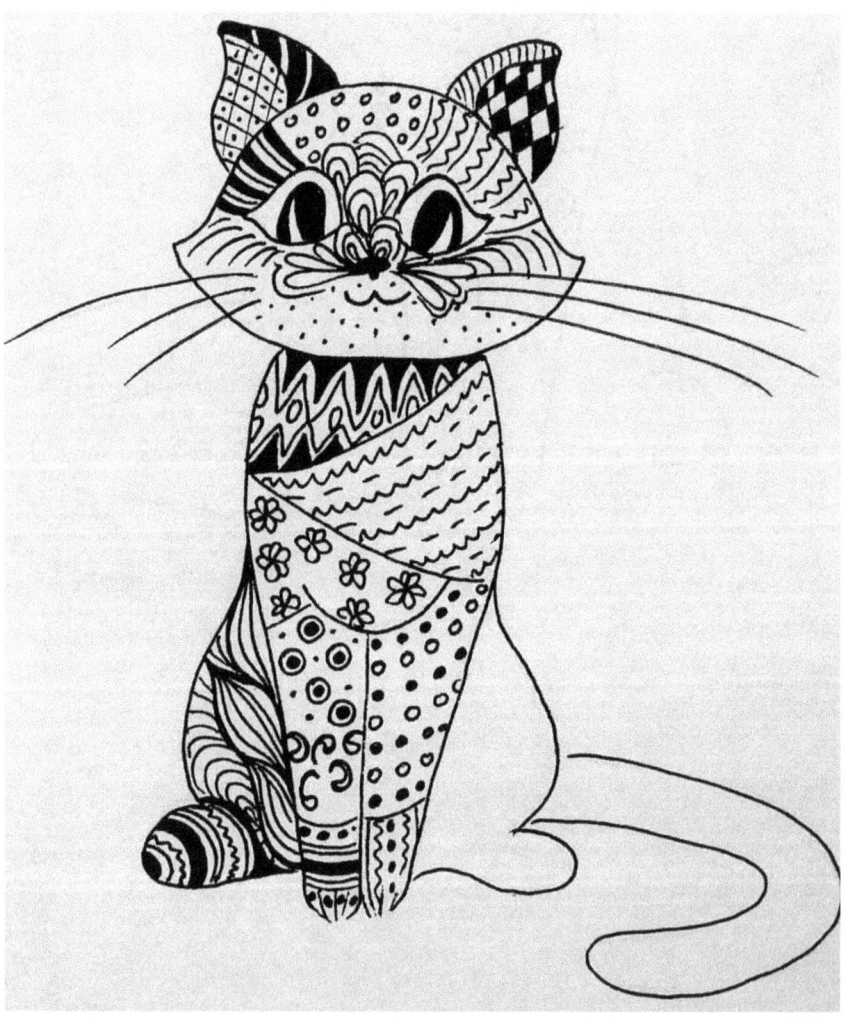

Step 6

Draw some "*" shapes in the right portion of the lower body. Draw some incomplete flowers in the right foot at the edges and insert some little dots in the remaining portion of the lower body.

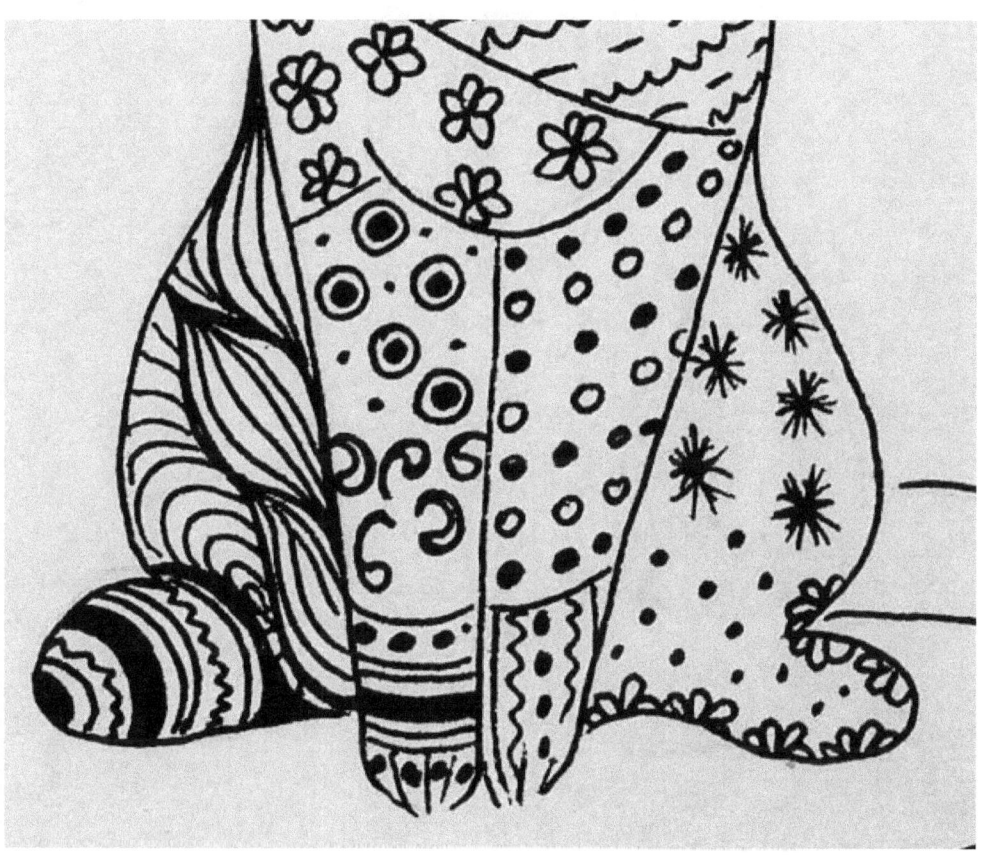

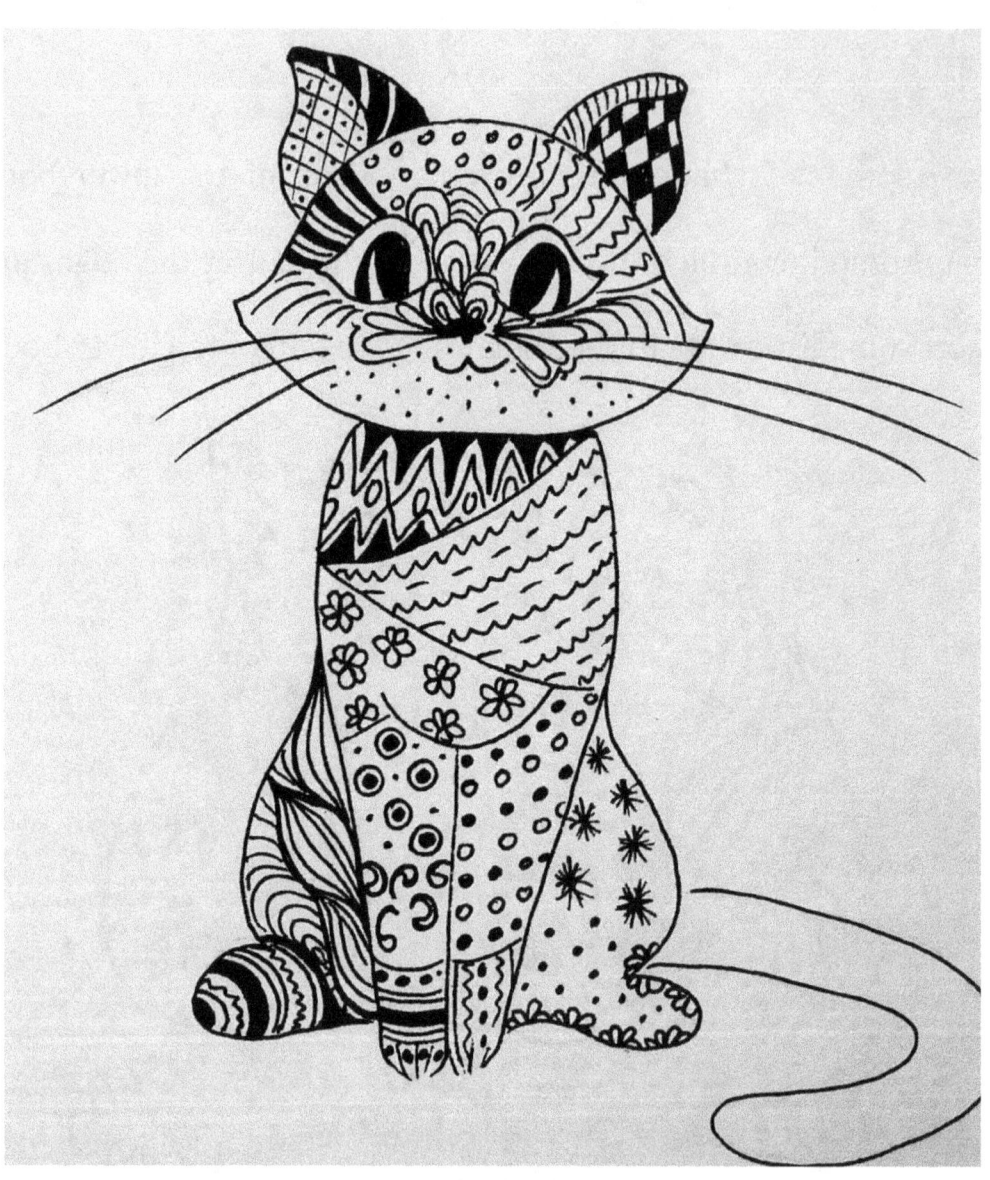

Step 7

Draw horizontal lines to fill up the tail of Casper. Fill up a few sections with ink, draw zigzag lines randomly, and draw underscored lines in between some sections. You can also insert scallops and bullet trails somewhere between these sections.

The drawing of this beautiful submissive cat, Casper is complete.

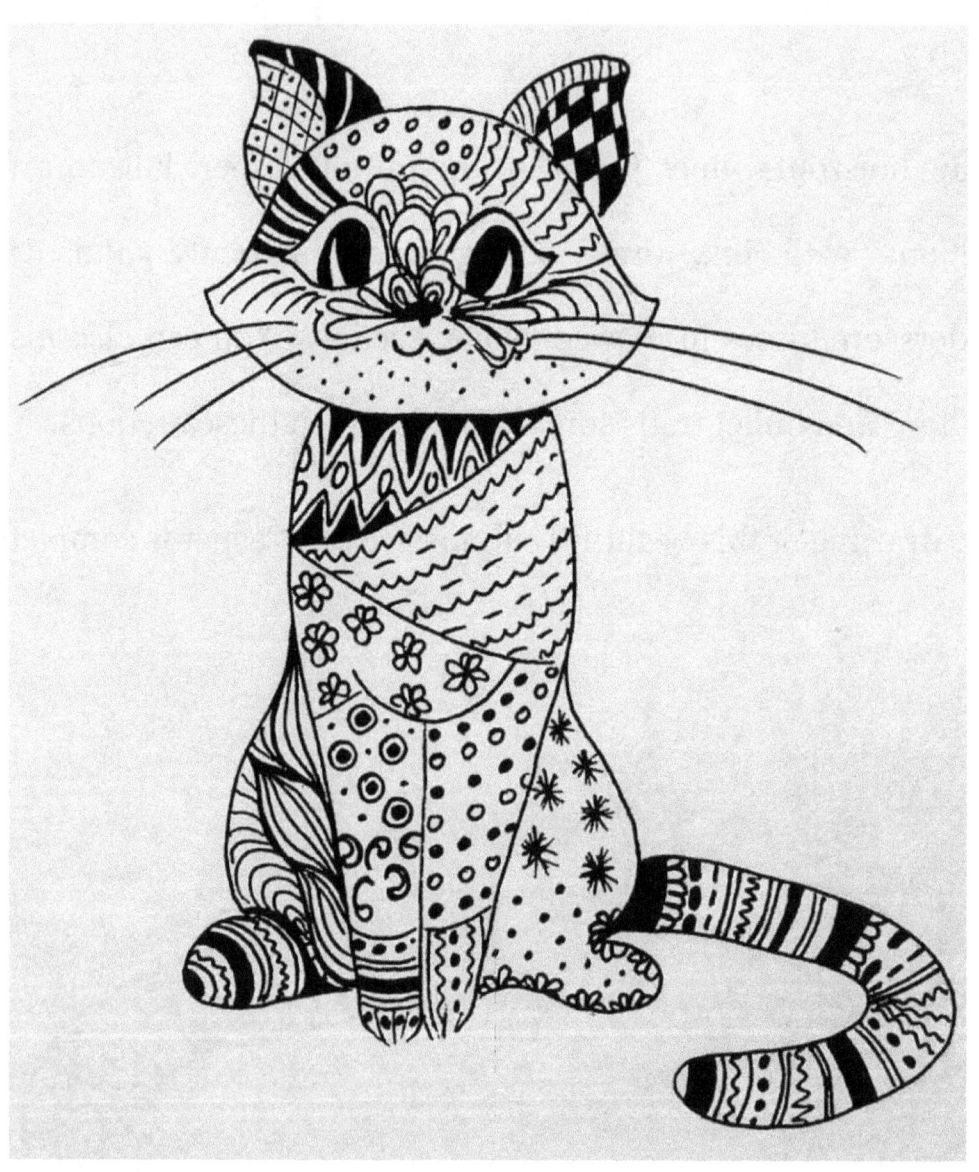

Chapter 4 How to Draw Pumpkin

This laidback plump cat, Pumpkin is an ideal addition to a family. He would never extend his claws if you were playing with him. And, you would not expect but he can be a model for you if you want to dress him up. You can take him to the park in a baby buggy or even make him a guest at your tea party. Since he is large in size; your children can get a cozy feeling with them.

If you want to hold this heavyweight Pumpkin cat in your hands, you have to be very careful. Do not let his hind legs drooping down if he is in your arms. Nevertheless, Pumpkin is a friendly cat and he can even be friends with your dog. If you introduce other pets carefully to him, he can be amiable with anybody on Earth. Let us learn how we can give a different look to Pumpkin using Zen Doodle technique.

Step 1

Pumpkin seems to be looking at someone to play with him. But, he is worried about who will carry him because he is too heavy to be handled by kids. Keeping his feelings in mind, draw his basic outline and notice the worried expression in his eyes. His forelegs are in front of him while he is sitting. His ears are slightly protruding upwards. His tail is resting on the floor.

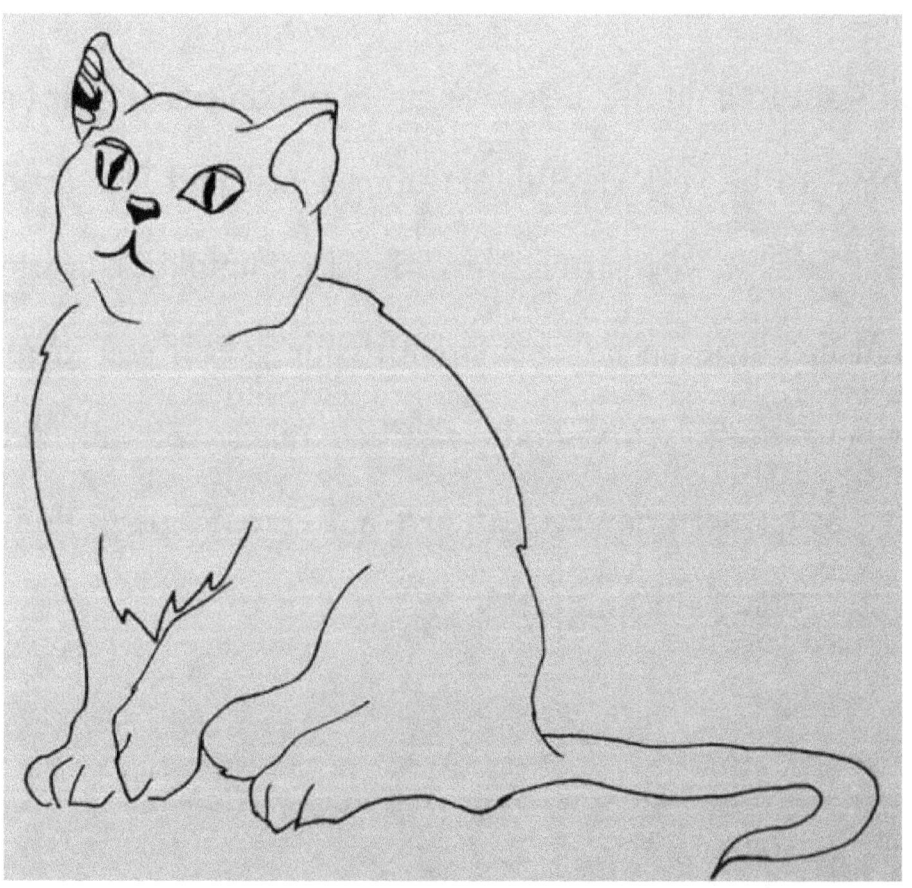

Step 2

Now Pumpkin may not look as it looked only in the outline but we are exploring his drawing in Zen Doodle. Fill the ears of Pumpkin with patterns of ovals, diagonal lines and zigzag lines. Draw scallops based on one middle line between the eyes, from forehead to nose. Draw drop shaped horizontal shapes beneath the nose and draw congruent lines around them.

Draw a flower like pattern below the mouth. Draw an arc on the right side of the face and draw parallel arcs at some distance around it. Insert small circles in the space between the arcs. Draw some flowers and insert a few little bullets in the remaining space. Draw two leaf-like patterns in the left side of his upper body and enclose them.

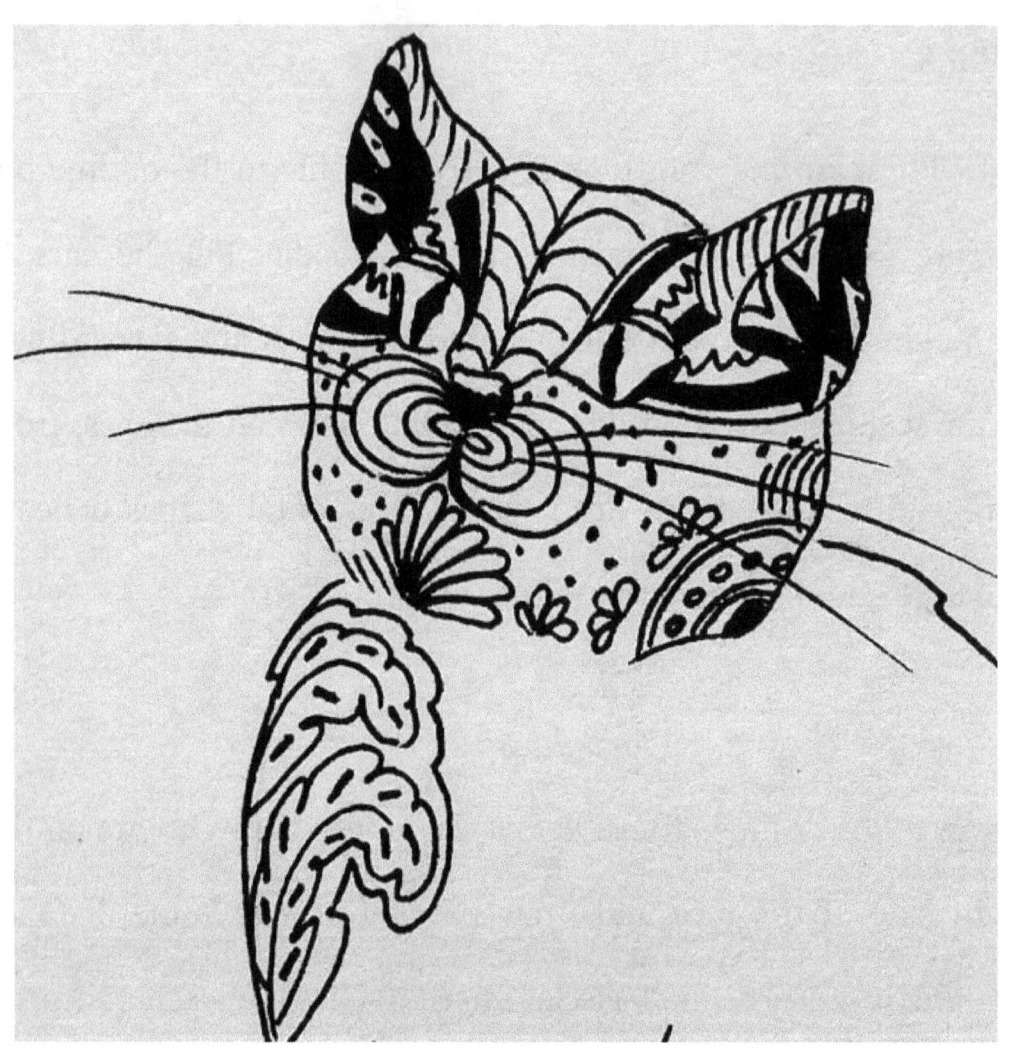

Step 3

Draw inverted drop shapes in the left foreleg. Draw a similar shape just beneath the face and thicken the outline. Draw a few congruent lines around it and enclose it with a scallop shaped line. Use "V" shaped design to border the scallops and insert circles around it.

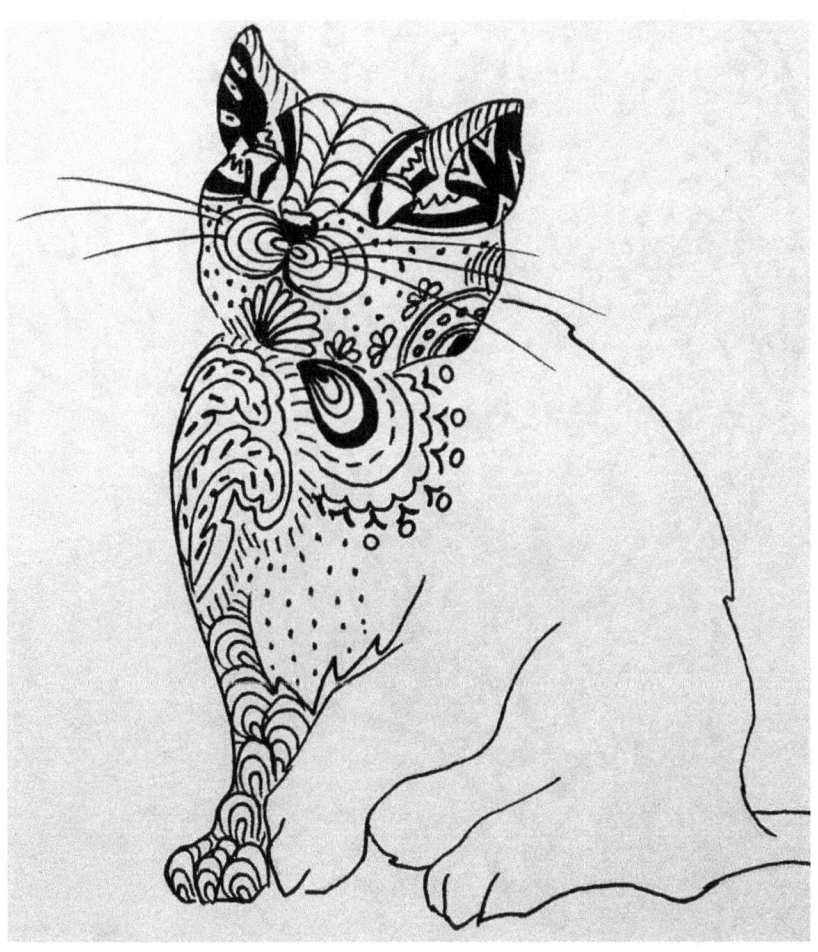

Step 4

Insert leaf-like patterns, inverted drop shapes in the right foreleg, and add V-shapes, vertical lines and circles in the body. Around the previous scallop line, add another parallel scallop and draw silhouettes of drops around it.

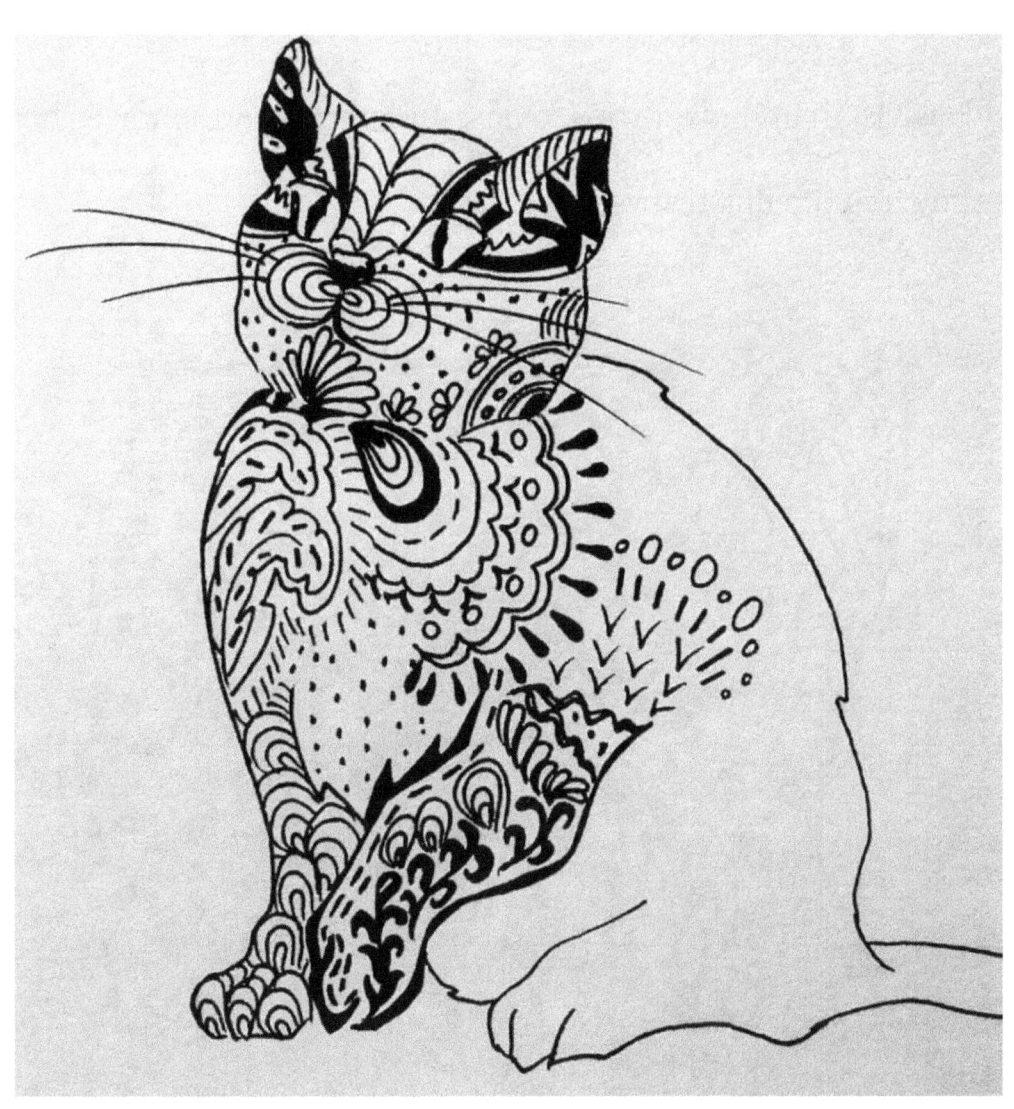

Step 5

Add swirls, diamonds, drops, ovals, and circles in the lower body as shown in the illustration.

Step 6

Draw patterns like scallops, vertical lines, drops, horizontal lines, zigzag lines, etc. in the tail and fill up the tip to complete the drawing of Pumpkin.

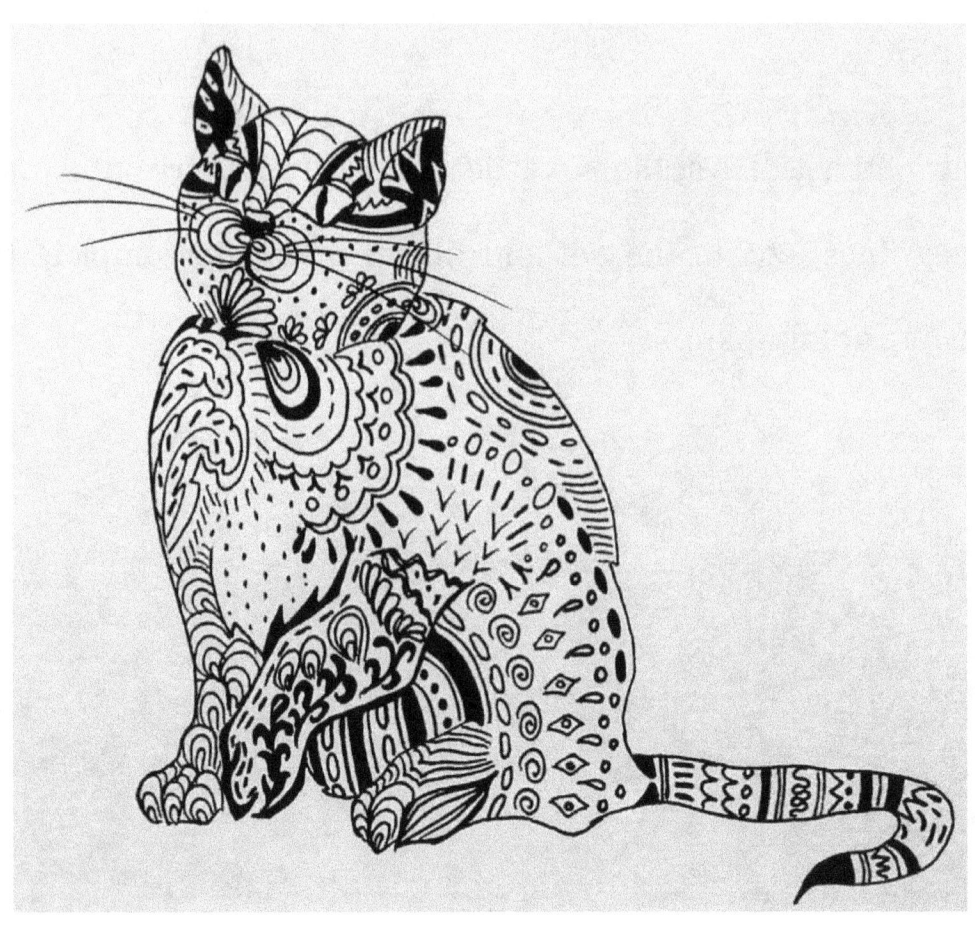

Chapter 5 How to Draw Kiki

Kiki is a Sphinx cat and is very brainy as compared to her friends mentioned in the previous chapters. She is muscular and quite heavy but she does not look like that though. The upper corners of her eyes are slightly round and the eyes are wide. Though she looks sharp, but she is a friendly cat. You can see that she has prominent cheekbones, which give her an Egyptian look.

There is one noticeable thing that she does not have whiskers. Her pot belly looks very cute when she walks after having her hearty diet. Let us see how we can make her over with our Zen Doodle equipment.

Step 1

Draw the outline of Kiki, half laid on the floor as if she has just woken up to look at a surprising thing. Her eyes seem alert and she has a thick lower edge of eyes giving them a kohl-like appearance. Her mouth and nose are joined that give an astute look. One of her hind legs is hidden behind the other.

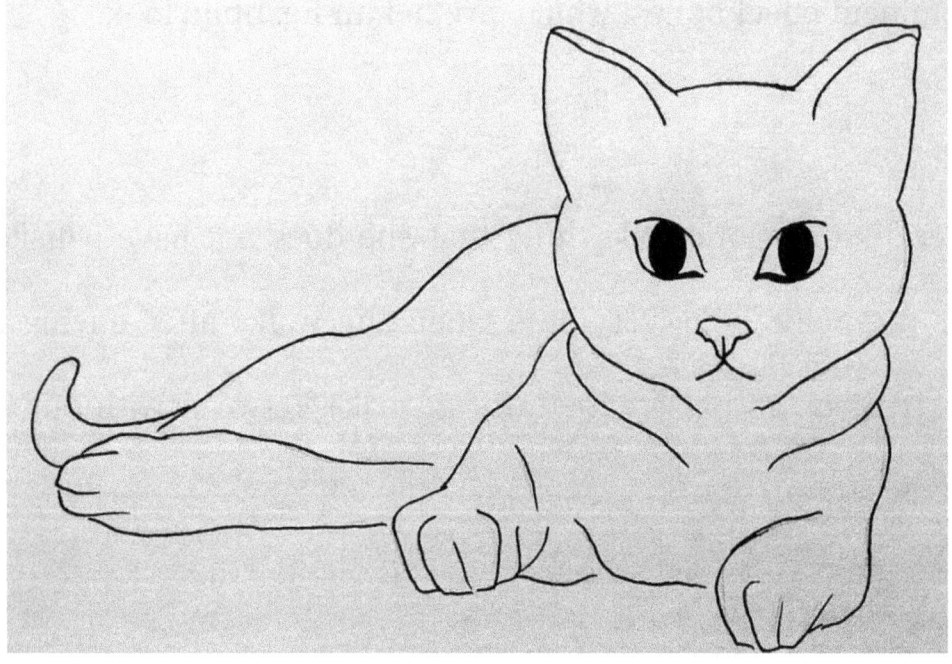

Step 2

Draw a few inverted drop shapes in the tail and hind legs of Kiki. Add a few vertical lines to divide sections in the posterior of her body and insert a few zigzag lines in between. In the hind leg, add infinity signs and a few underscores.

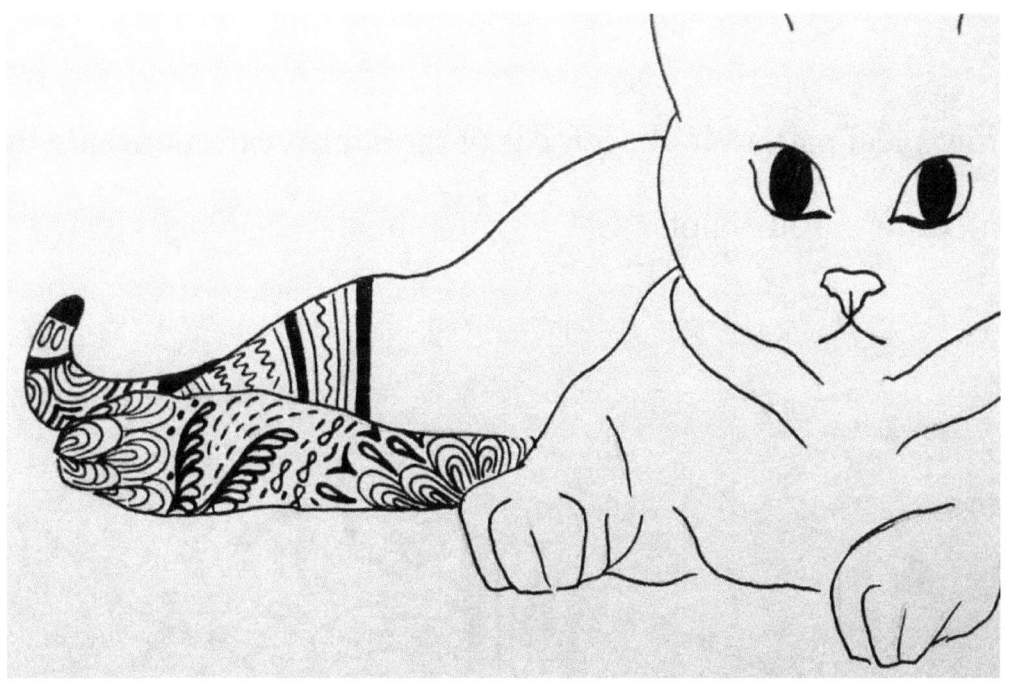

Step 3

Add a flower in the body where the vertical lines ended. Draw a scallop to enclose this flower and add a few butterfly-like shapes above this scallop. Draw enlarged comma shapes and inverted scallops above them. Complete the drawing in the posterior body of Kiki.

Draw a leaf pattern in the left ear of the sphinx cat. Alongside this leaf, draw a trail of dots.

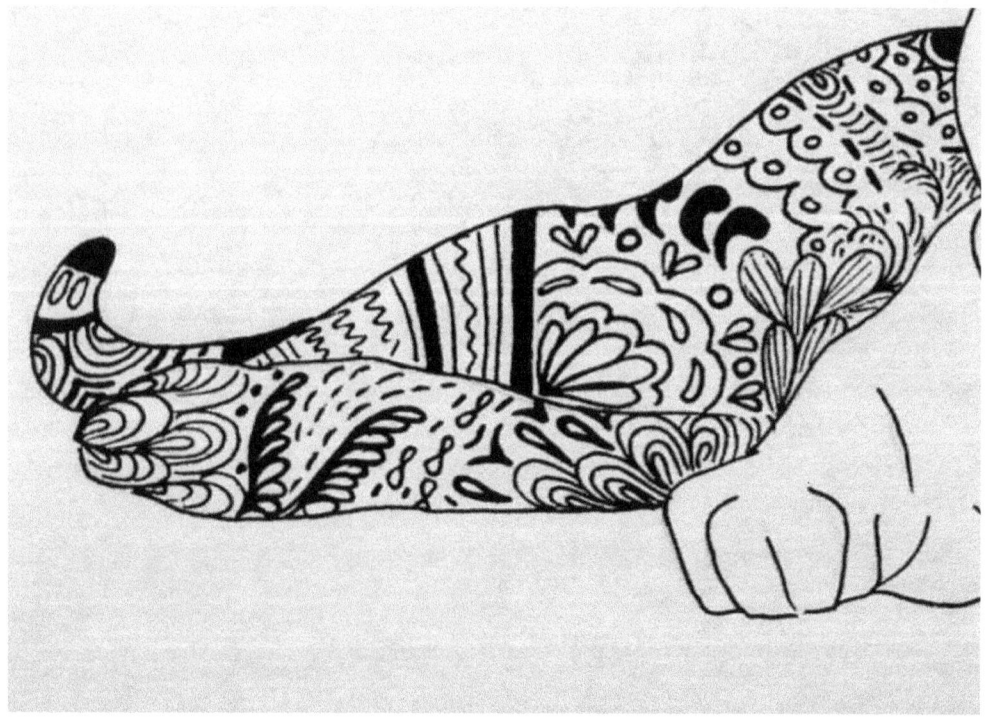

Step 4

Draw another form of leaf pattern in the right ear and draw a trail of dots on both sides. Draw the similar trail in negative on the left side in the same ear. Beneath the left ear draw some "+" signs, swirls, etc. Draw a trail of bullets between the eyes diagonally and enclose them with circles. Enhance the shape of nose as shown in the picture.

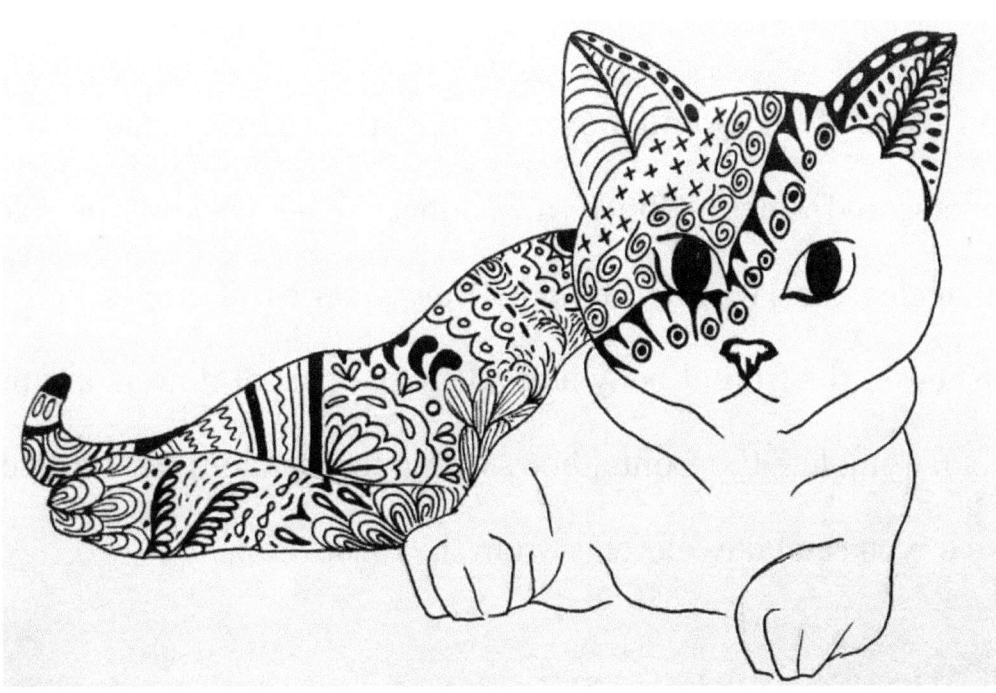

Step 5

Add some"*" signs and waves around the right eye along with underscored lines. Notice a distinct shape below the face enhancing the jaw line of Kiki. Draw a series of circles tied to bushes on the frontal body and add some partial flowers around them. Complete the frontal body with a few random patterns you like or you can take reference from the illustration.

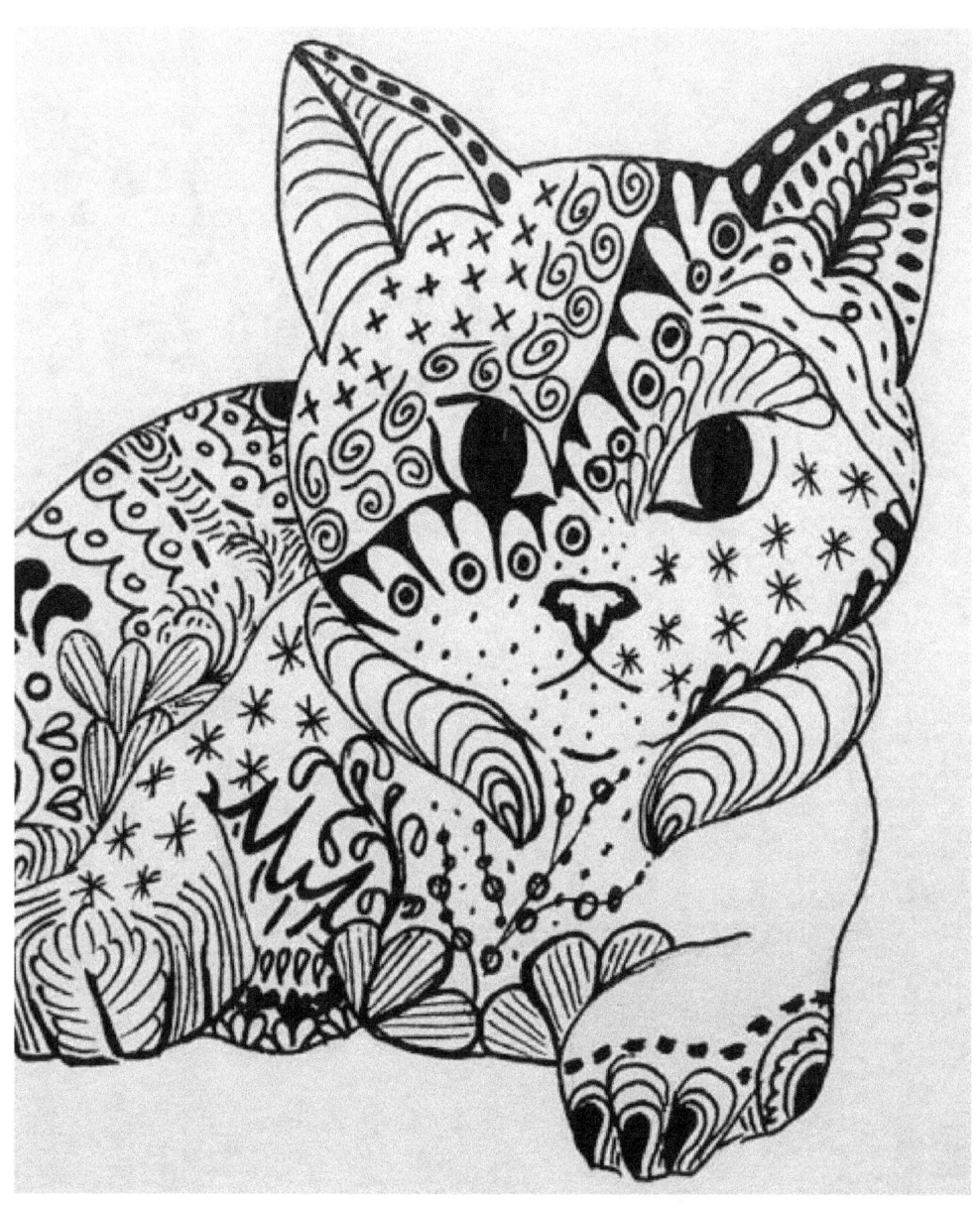

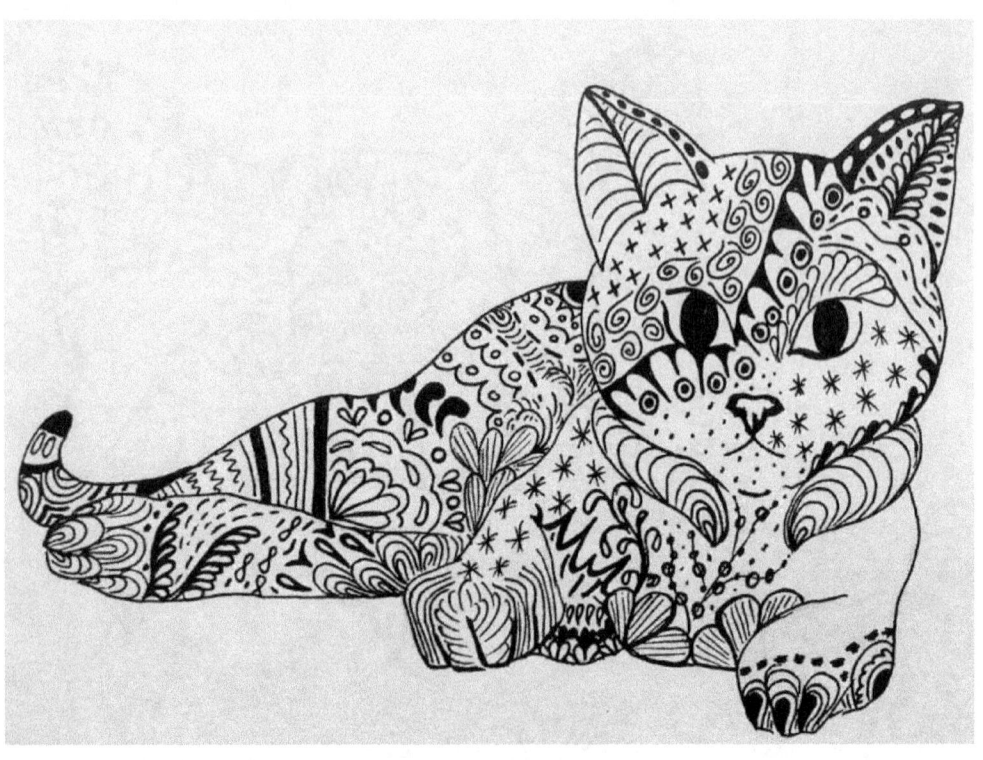

Step 6

Add a few flowers in the right forelimb and surround them with a few little dots. Draw inverted drop shapes enclose them with a few parallel and congruent lines. Draw a few patches of horizontal lines around the drops.

The drawing of sphinx cat, Kiki is complete.

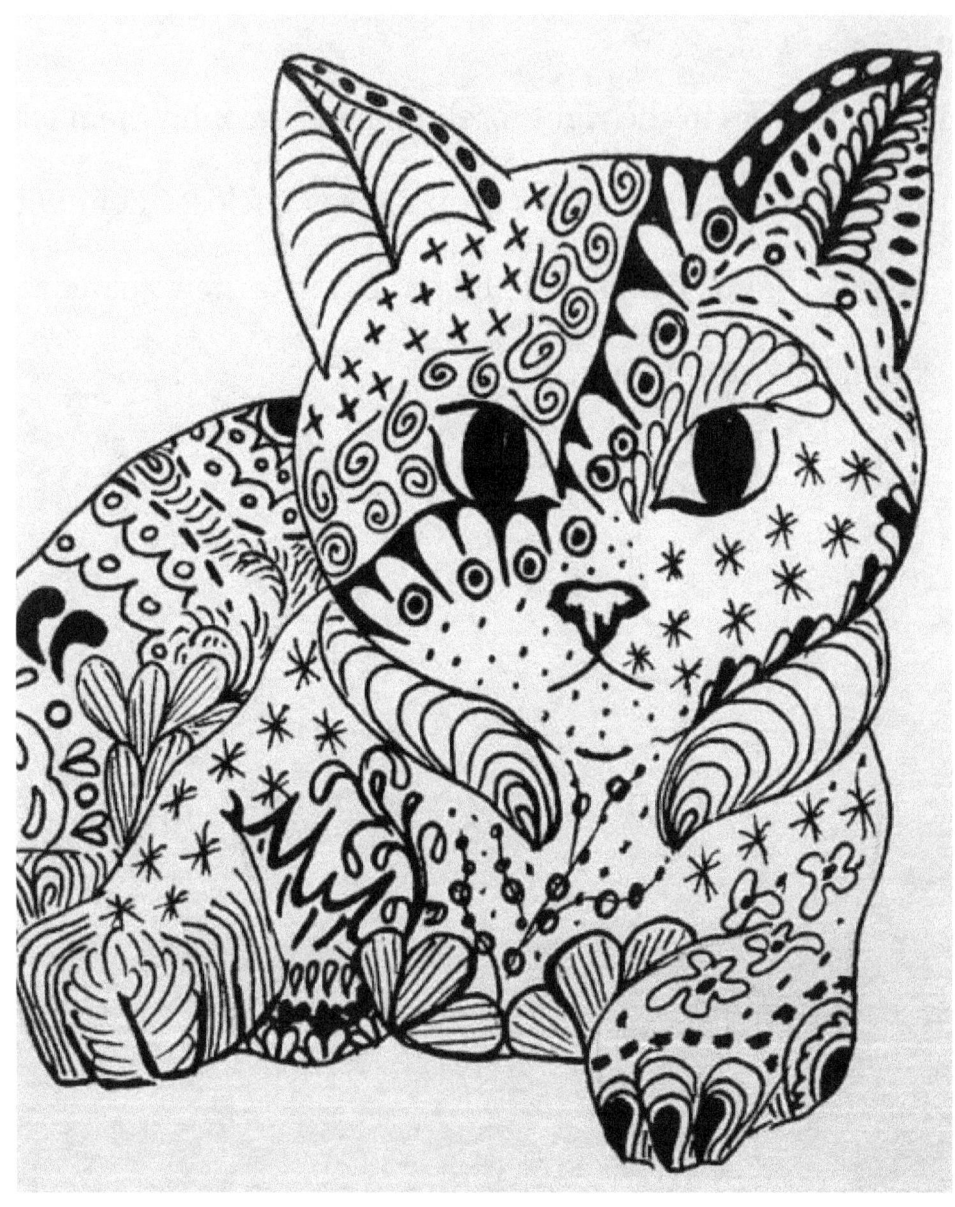

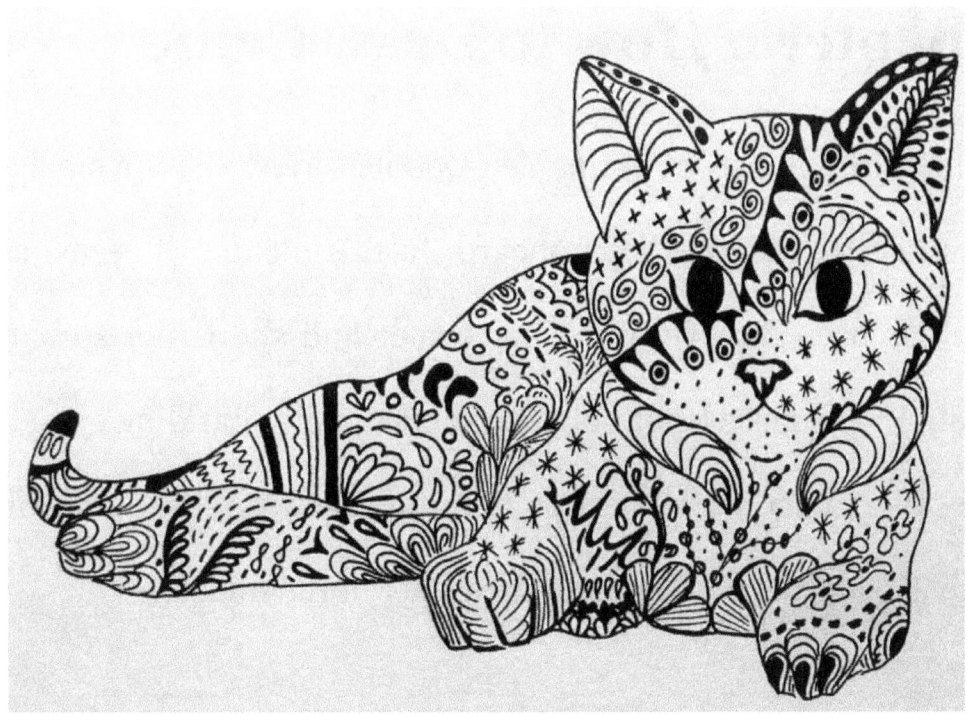

Chapter 6 How to Draw Callie

Callie is the cutest cat of this Zen Doodle series. She is a small cat who likes to hide in the cupboard. In this picture, it seems as if she has been discovered by her owner and she is not so happy about it. She has a bright big nose and equally sparkling eyes. She does like to play with children but most of the times, her favorite activity is to sleep in her favorite corner of the house.

You can be her best friend if you give her her favorite kitten food and let her sleep. Only, then she will feel fresh enough to play with you in the evening. You can never guess how playful she can be once she gets into the mood. Let us give her a new look with our Zen Doodle pen.

Step 1

Draw the outline of Callie using a free flow of your pencil. Her ears are large and are projected upwards. Her big oval face consists of small oval eyes and a slightly larger nose. Her mouth is depicted by only a diagonal line gesturing a smirk. Three of her paws are visible because of the way she is sitting. Her tail has come in front of her body.

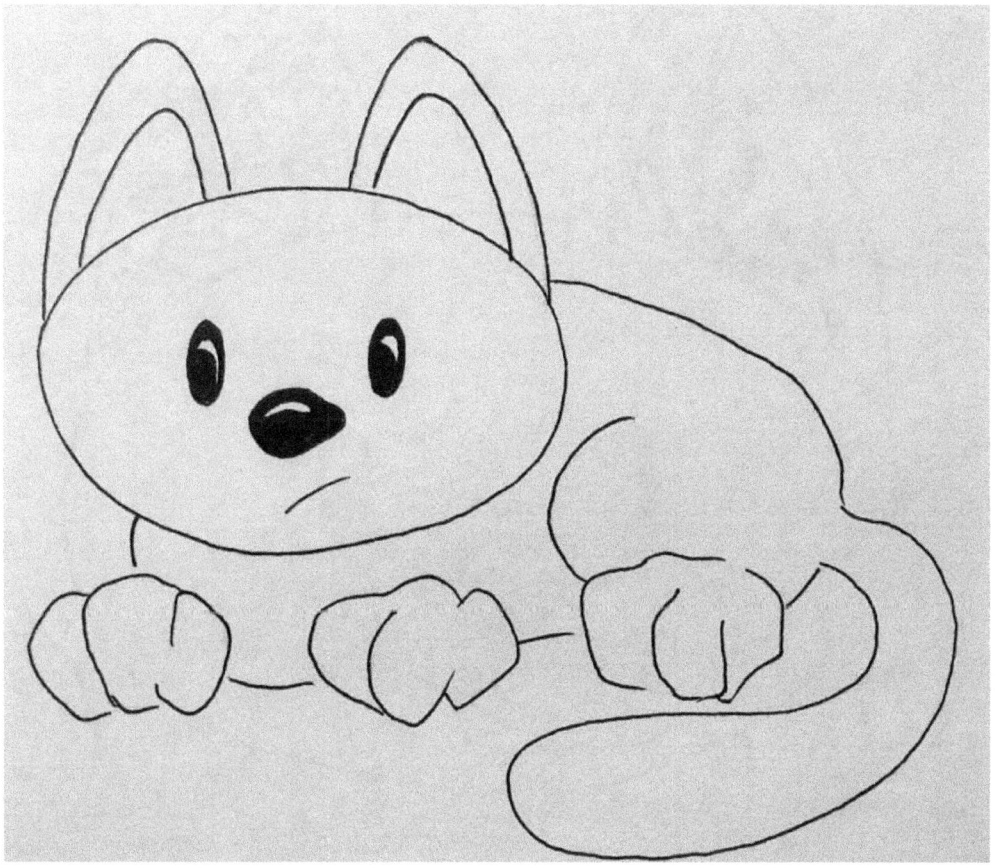

Step 2

In the left ear of Callie, draw a football like pattern of lines in the smaller section and use a combination of vertical and horizontal lines to surround this section. In the right ear, use a beautiful pattern of partial flowers and surround them with negative flowers and small circles.

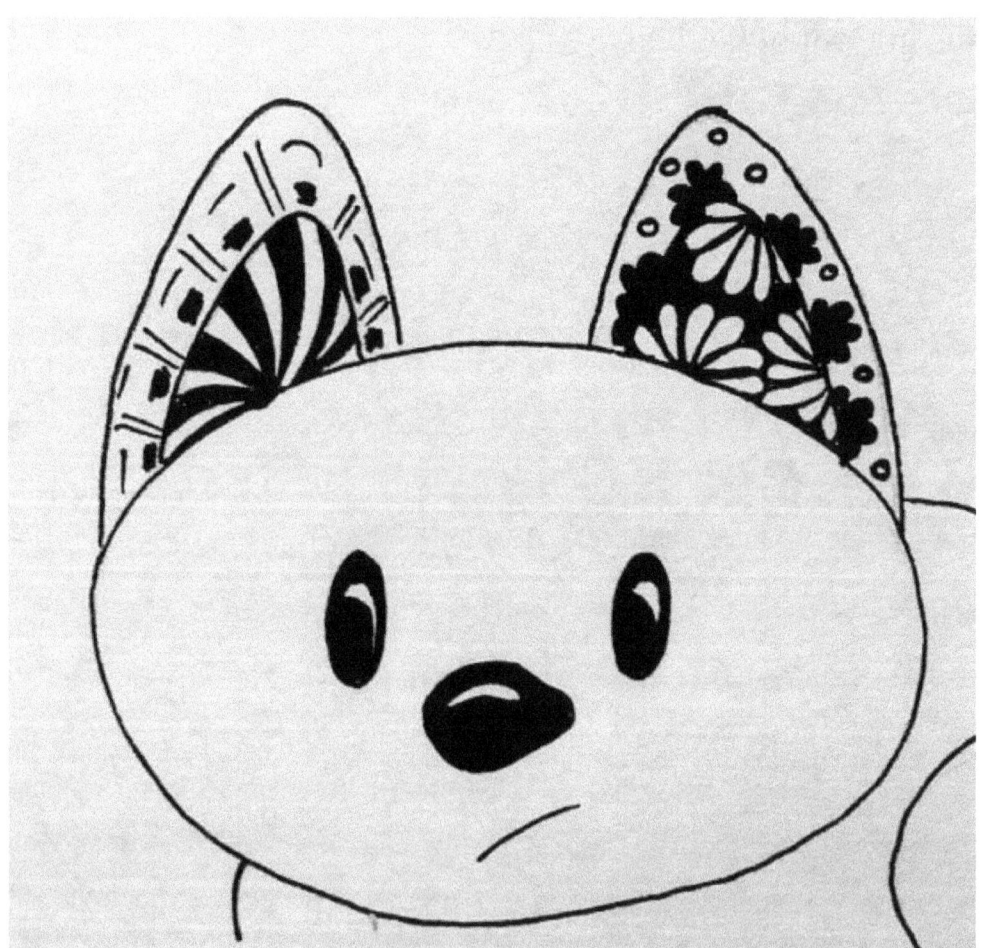

Step 3

Staring from the nose, draw the upper face into three sections. In the middle section, draw a few ovals and pass a line through their center. Add a few more vertical lines around the lines of axis in the ovals. Insert a series of zigzag lines in the rightmost section.

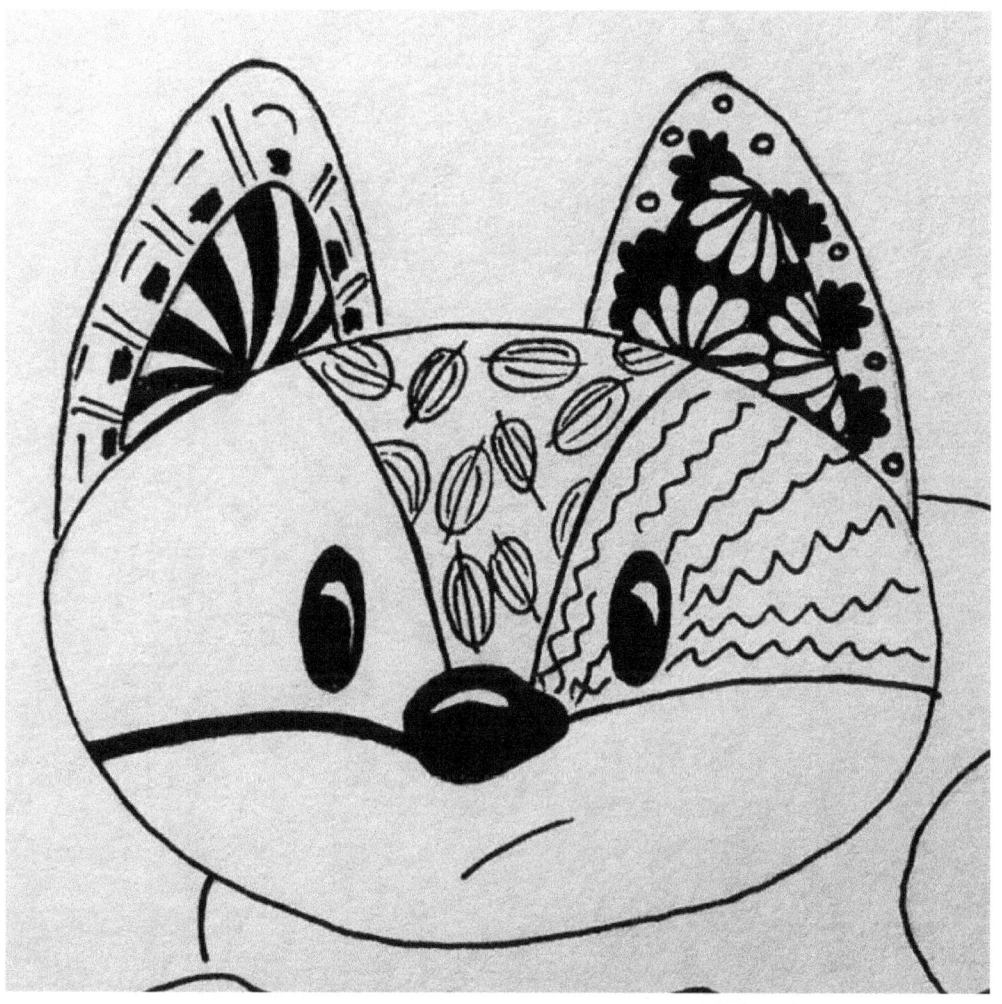

Step 4

Draw a few leaves in the leftmost section of the upper face. In the lower division of the face, draw a few circles and bullets. Leave a few circles incomplete to create a different pattern.

In the leftmost paw, draw curved vertical lines, scallops, and checks.

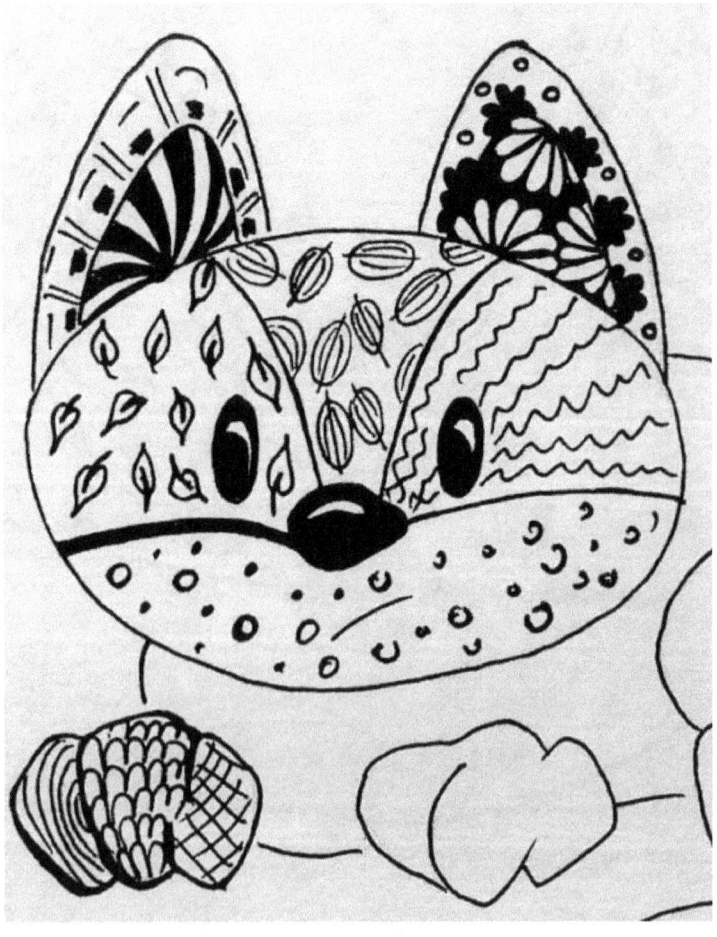

Step 5

In the frontal part of the body, insert fire pattern, zigzag lines, drop shapes, star shapes, diagonal lines in various settings as shown in the picture.

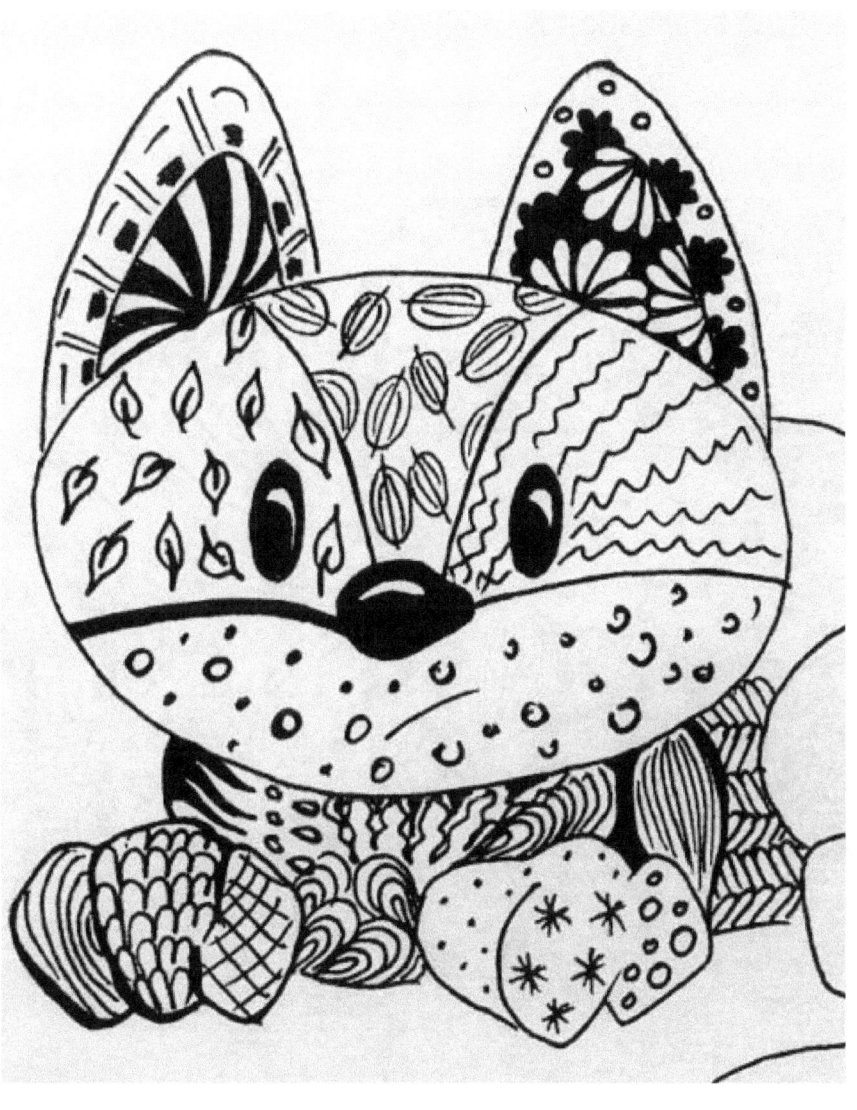

Step 6

In the posterior section of the body, draw a few parallel arcs in different directions as shown in the illustration. Add a few circles in between some arcs and fill up their surroundings with ink. Insert spring and swirl shapes in some arcs. Similarly, use thick underscores, heart shapes, dots, bullets, and circles to cover the area.

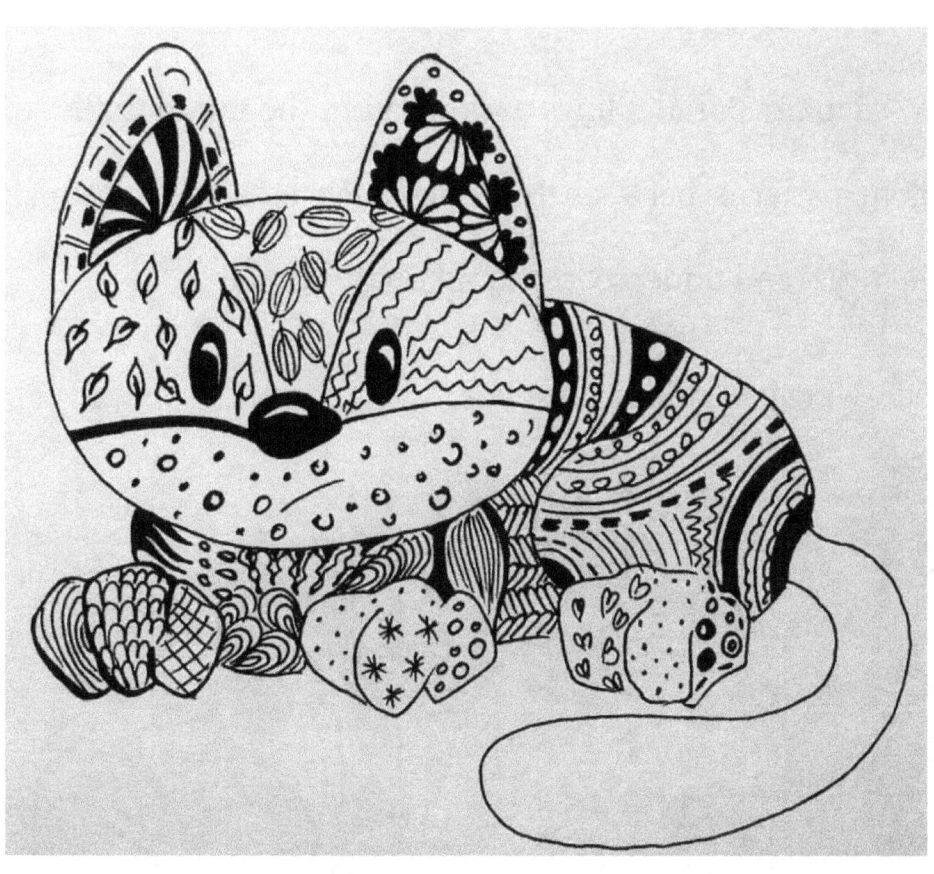

Step 7

Draw as many parallel lines as you can in the tail of Callie. Insert random patterns between the lines such as star shapes, zigzag lines, ovals, and underscores to fill up the area.

The drawing of Callie is complete.

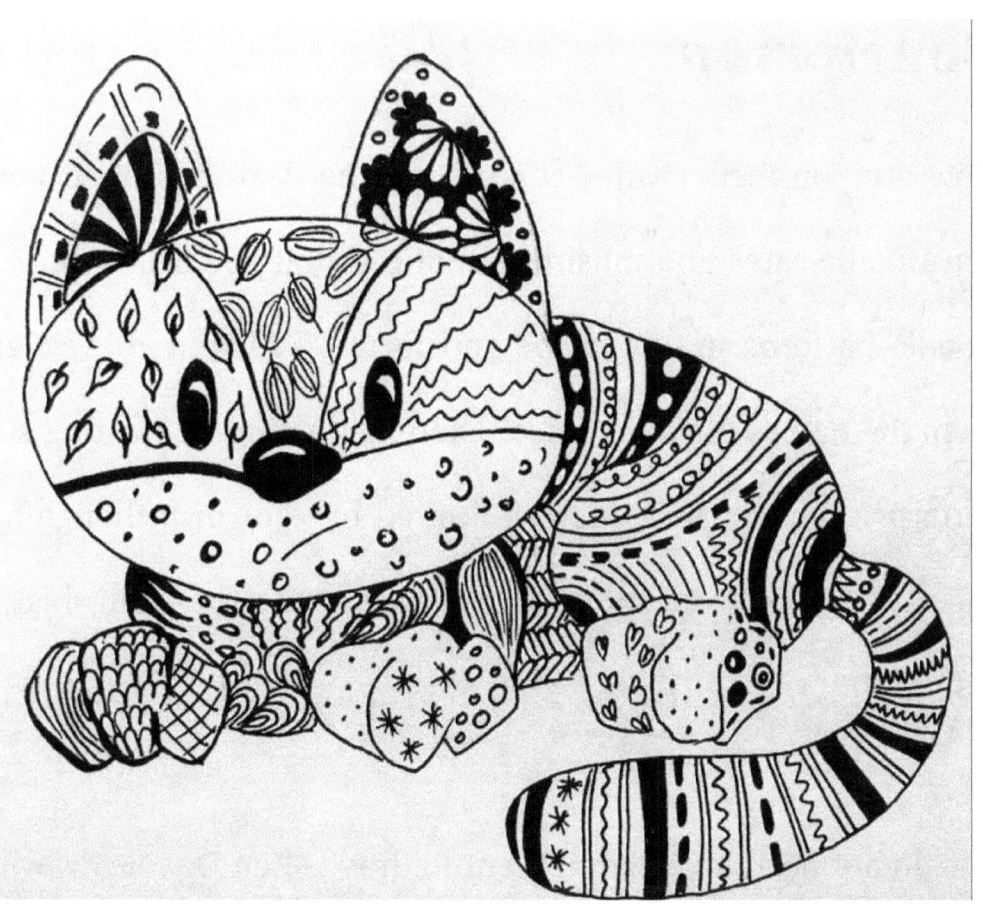

Conclusion

How are you feeling after completing the drawings of so many Zen Doodle cats? You must have noticed that you can create Zen Doodle patterns in any shape and form you like and even give them the names of your choice. There is no limit to creating such patterns. Your creativity is just limited by your own thoughts. If you have a pet cat at your place, she can be your biggest inspiration.

You do not need much equipment to draw a Zen Doodle drawing. Only a pen, pencil, ink, and paper are enough. Make a few tiles of blank white paper of 4 inches X 4 inches. Take these tiles along with you wherever you go and create new patterns whenever you are sitting idle. This little trick can take you a long way in creating many interesting things than you would have thought.

When you are out of your comfort zone, your mind races faster than normal and your thought process is much better. Look

around you and find inspiration in creating new Zen Doodle designs. You will come out with much better things than you would do if you just sit at home and *decide* to draw. Spontaneous creations are far superior to the intentional ones.

However, this does not diminish the value of regular practice on purpose. It is essential that you devote a few minutes or even hours every day to your practice of Zen Doodle drawings. This will help you in staying motivated to draw more and more designs and perfect in the same. It is not at all very difficult to master Zen Doodle. Nevertheless, you require regular practice to leave the stage of being an amateur and achieve the level of an expert. When your mind is satisfied with what you have achieved, you are successful in true sense regardless of what people might tell you.

This book is just a starting point for those who have picked up the Zen Doodle drawings for the first time. However, there is no

stopping you if you decide. You can motivate yourself as much as you can or even seek motivation from external sources. We hope that this book helped you in starting your journey and we wish you best of luck in going ahead!

Thank you!

Thank you for choosing our book, we hope you found it interesting and helpful.

If you liked the book, please give us a favor to write your review here:

We would really appreciate this!

If you would like to have a bonus – **FREE BOOK**, please send the screenshot of your review to this e-mail: **lucy.artbooks@gmail.com** and we will send you a **FREE BOOK** in PDF as a **GIFT**!**

Hope to see you in our future books and good luck in your drawing experience!

**** in the e-mail subject please mention the name of the book you reviewed and the author.**

Other books from Daniele Ling

ZEN Animals: A Complete Guide to Master Wild Animals Drawing in Zen Doodle

Zen Doodle Cats:
Drawing Zen Doodle Cats Made Easy

Drawing People In Zen Doodle Technique: Unleash Your Creativity with Unique Zen Doodle People Drawing

Zen Doodle Imagination: Create Your Own Zen Doodle Drawings Easy!

Zen Dogs Drawing:
Learn how to Draw Your Favorite Dogs with Zen Doodle!

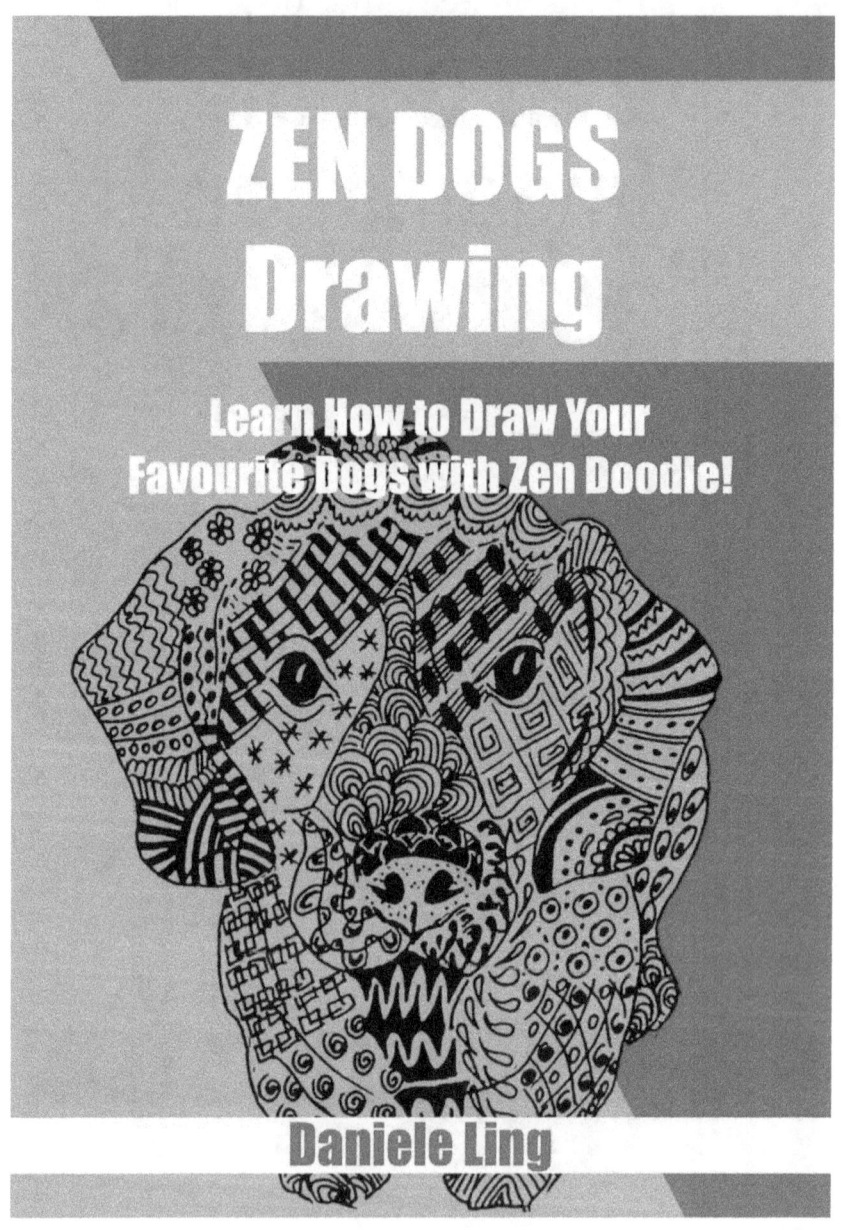